D0186833

Coloured Pencils

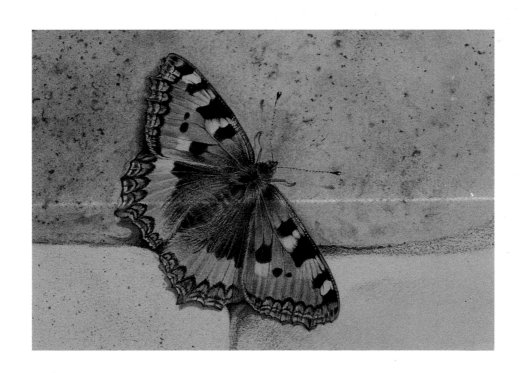

DAVID COOK

For Joseph, Thomas, Annabel and Emily – my grandchildren

Acknowledgements

I cannot claim total credit for this book. Many others, too numerous to mention,
have played their part, but I do wish to thank Arjo Wiggins, St Cuthbert's Mill and Sappi for
supplying the various papers used, as well as Caran d'Ache, Schwan Stabilo and Chromacolour
for their crayons, pencils and paints. Especially I thank Acco UK and Daler-Rowney for their
generous support in supplying all other art materials used in this book.

Thanks, too, to Caroline Churton of HarperCollins for her expertise, kindly
guidance and, above all, her unlimited patience; she, like my wife Anne, helped me to
continue the book despite other commitments and two house/studio moves from Cumbria
to Norfolk within six months! Patsy North, Caroline Hill and Jon Bouchier
provided expertise in their particular fields. All have been invaluable
and I gladly acknowledge their contribution.

First published in 1999 by
HarperCollins*Publishers*
77-85 Fulham Palace Road
Hammersmith, London W6 8JB

The HarperCollins website address is:
www.**fire**and**water**.com

00 02 03 01 99
2 4 6 8 7 5 3 1

© David Cook 1999

A catalogue record for this book is available from the British Library.

Editor: Patsy North
Designer: Caroline Hill
Photographer: Jon Bouchier

A video, *Exploring Watercolour Pencils*, is available and may be obtained from Daler-Rowney Ltd,
P.O. Box 10, Bracknell, Berkshire RG12 4ST

ISBN 0 00 413320 X

Colour reproduction by Colourscan, Singapore
Printed and bound by Printing Express Ltd, Hong Kong

Contents

Page 1: **Tortoiseshell Butterfly on Cobbled Stones**, 15 x 20.5 cm (6 x 8 in)
Opposite: **Annabel**, 30.5 x 22.5 cm (12 x 9 in)
This page: **Kathy's Jar**, 45.5 x 22.5 cm (18 x 9 in)

Portrait of an Artist

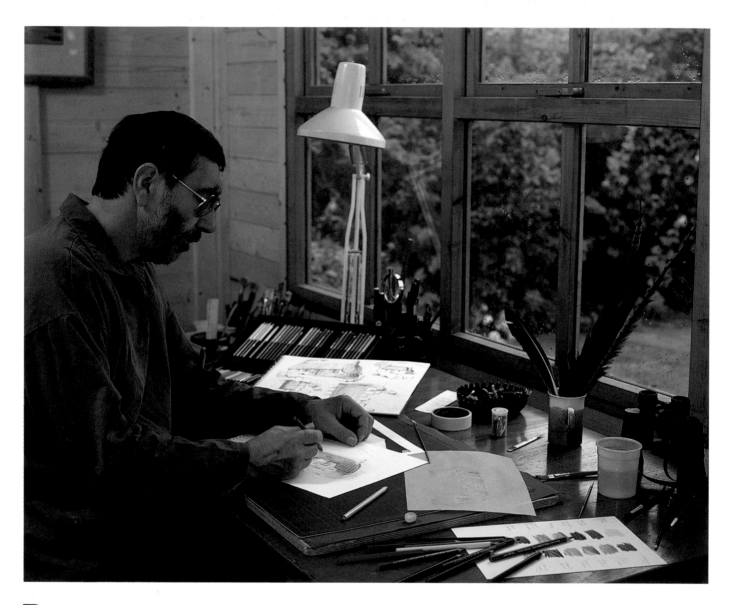

B orn in Kent, David has always been interested in natural history and fascinated by paper. He was encouraged in all forms of art and craft from an early age.

He was invited to study at the Medway College of Art in Rochester and further study at the Regent Street Polytechnic in London gave him a thorough foundation in art and photography. Combining this with his love of nature, he joined *Country Life* magazine as an assistant photographer. Working with famous artists and royal photographers enhanced his appreciation of the visual image and the impact it can create. Research and investigative photography for a leading paper manufacturer led to police service and eventually the Law.

Art was an all-consuming hobby until 1970 when, 'discovered' by a provincial gallery, David was introduced to The Society of Wildlife Artists. His work has been shown and sold at The Mall Galleries in London ever since.

▲ David Cook at work on a coloured pencil drawing in his Norfolk studio.

Helping a charity through his art brought David into contact with the Cumberland Pencil Company and the Derwent range of pencils on which he is an accepted authority. By developing, testing and advising on pencils, demonstrating his own innovative techniques at major art and educational shows, teaching in residential colleges, making two videos, and writing and illustrating numerous magazine articles, David has been able to encourage others to examine pencils afresh and enjoy using them to create fine art. He has given workshops in America, Canada and Japan. In addition, as an Artist in Residence at Wallsworth Hall – the International Centre for Wildlife Art, whose collection includes his artwork – he gives illustrated talks and tutorials annually.

To inspire other artists to strive for perfection – a self-confessed objective – David inaugurated and continues to sponsor the PJC Award for Individual Merit, now in its thirteenth year, in conjunction with *British Birds* magazine within the Bird Illustrator of the Year Awards at The Mall Galleries. He has received awards himself, including a Natural World Art Award, and has had artwork auctioned – at Christie's amongst others – in aid of wildlife conservation. His paintings are published annually to the benefit of the Royal Society for the Protection of Birds and the Wildfowl & Wetlands Trust.

David's drawings, paintings and paper sculptures are featured in several books and are in civic, corporate, educational and private collections worldwide. He has broadcast on radio and been featured on regional and national television.

Known for his realistic, extremely detailed artwork, David is increasingly exploring the abstract shapes found within nature in his drawings, paintings and papercuts. He says he is still striving for perfection!

▼ **Barnacle Ben**
Coloured pencils
12.5 x 28 cm (5 x 11 in)
This barnacle goose was drawn in Delft Blue, Raw Umber and White Derwent Studio pencils on toned Keaykolour paper to benefit a children's charity.

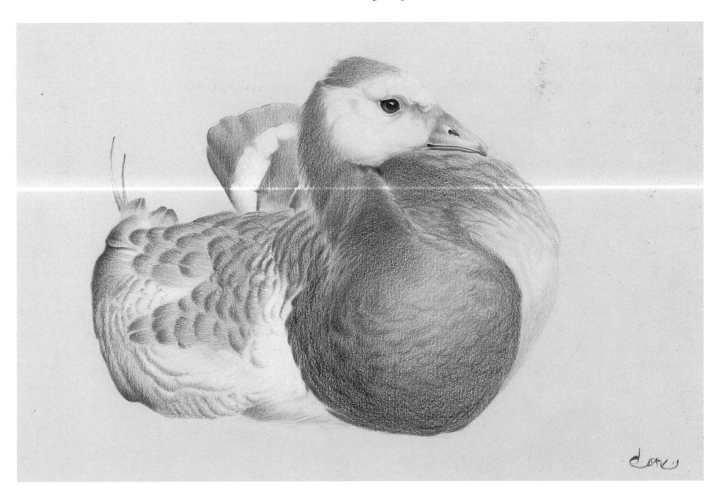

The Versatile Coloured Pencil

Coloured pencils are ideal for the beginner, confused perhaps by the great variety of art products available. There is something reassuring in using pencils. As children we called them crayons and grew up writing and drawing with them, expressing ourselves in line and tone just like our ancestors. But instead of caves, our earliest masterpieces were scribbled on wallpaper or chalked on to walls.

Because pencils are so familiar, whether graphite or coloured, being able to paint with them is less daunting and our confidence is therefore increased. But their very familiarity tends to exclude pencils from 'fine art'. Too often, they are underrated.

Coloured pencils are easy to carry and use – just pop a few in your pocket – and not too many are needed to produce a coloured drawing on a pad of paper. With soluble pencils add some water and a brush, and for crayons, a solvent like an alcohol blender. Crayons and pencils are relatively inexpensive and can be mixed among themselves – crayons with graphite, or pastel pencils with charcoal pencils, for example. They can also be combined successfully with several other media.

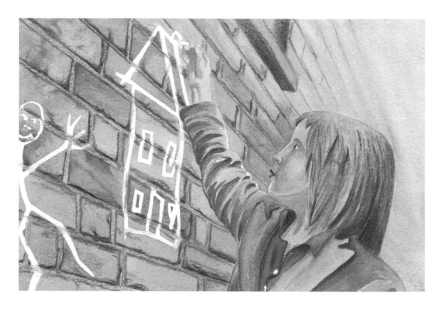

▲ **Girl Chalking on a Wall**
Mixed media
15 x 22.5 cm (6 x 9 in)
Both ordinary coloured pencils and watercolour pencils were used in conjunction with masking film to produce this picture. It shows just some of the many interesting effects that can be achieved with this versatile medium and illustrates how coloured pencils can be used as successfully for painting as for drawing.

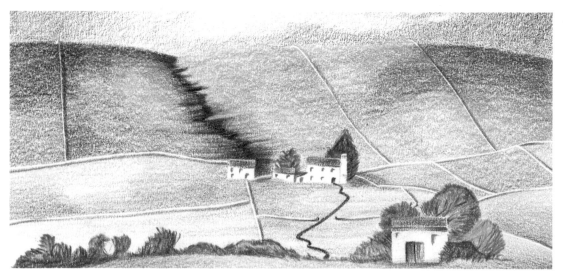

◄ **Fellscape**
Coloured pencils
14 x 28 cm (5 ½ x 11 in)
I impressed the paper with the blunt end of a needle to define the walls on the hillside and cut and positioned masking film for the houses before colouring with pencils.

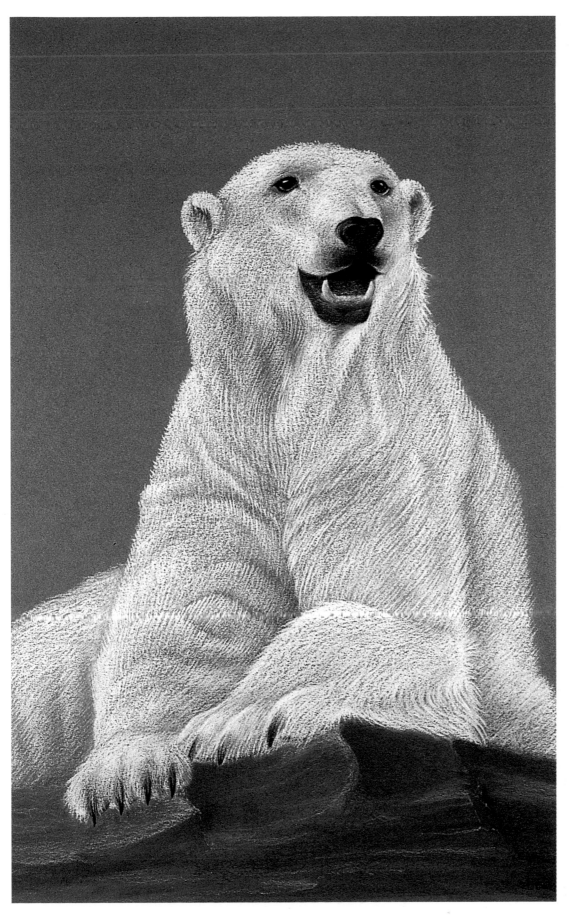

◀ **Polar Bear**

Pastel

45.5 x 30.5 cm (18 x 12 in)
Derwent pastel pencils
were used dry on a toned
paper for this drawing of a
magnificent polar bear.

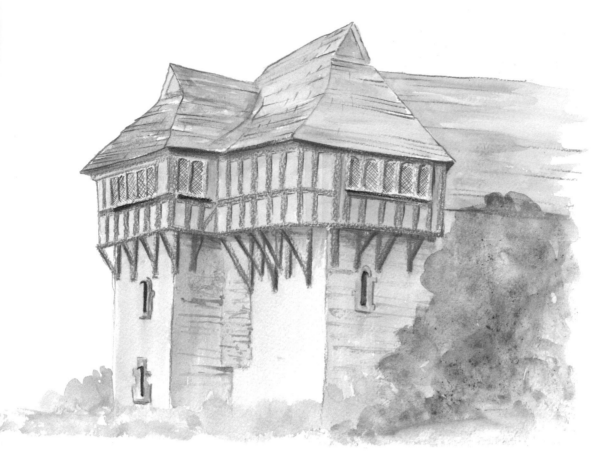

◀ Derwent coloured and graphite pencils were used for this sketch, with watercolour pencil washed over. Rather than try to capture the complexity of the whole building, I selected just an interesting corner.

▼ **Little and Large**
Mixed media
30.5 x 20.5 cm (12 x 8 in)
This picture was drawn in Derwent coloured pencils and Caran d'Ache oil-based crayons, then painted with solvent and watercolour pencils.

Origins of the pencil

Pencils were first made in Britain when, in the early 1500s, natural graphite was found in Cumberland, or Cumbria as it is now. During a storm, a shepherd in Borrowdale stumbled over the exposed roots of a fallen tree, so the story goes. He thought he had found coal in the disturbed soil but it did not burn, so in frustration perhaps, he threw the rest at a passing sheep. It found its mark – literally! – and a new drawing medium was discovered.

How a Borrowdale shepherd met an enterprising lady in Keswick, on the opposite shore of Lake Derwent, history does not say, but finding that the graphite could be shattered or cut into strips, she started a cottage industry. The graphite was bound into the split end of twigs and the first pencils were made. A romantic legend perhaps, but in essence the birth of the pencil as we know it, which to this day continues to be made in Keswick with established craftsmanship aided by machinery.

Pencil construction

Graphite is a form of carbon. Mistakenly called lead, the centre of any pencil is correctly a strip or core of graphite encased in a barrel of Californian cedar wood. All pencils, including coloured ones which are a mix of pigment and clay, are immersed in liquid wax to improve their drawing capability. They measure a standard 18 cm (7 in) in length.

Coloured pencils usually have round barrels. Some are hexagonal (not, as often stated, to prevent them from rolling off the drawing board) while others are flat. The logic behind these various shapes, which affect how the pencils are used, will be explained on page 16.

Fine art medium

Coloured pencils are normally thought of as just a drawing or colouring medium, but with the variety and versatility of those available today, painting can also be included in their repertoire. Most coloured pencils are derived from, on average, ten pure colours. These blended with white, grey and black usually make up the remaining colours in any range, which can be quite extensive.

Do not overlook 'ordinary' pencils, just because they are not brightly coloured. Black and grey are not considered colours as such, but should not be ignored in pencil form. Charcoal and graphite pencils will also be included – in passing – in this book in achromatic, monochromatic and mixed media applications.

In sharing with you some of the ways in which coloured pencils can be used, you will see that they are not just for children or limited to drafting out first ideas for a final painting. They are a fine art medium in their own right, as artists in the eighteenth century discovered. So, by the end of this book, you too will enjoy using pencils not only for drawing but to incorporate into artwork and to paint with.

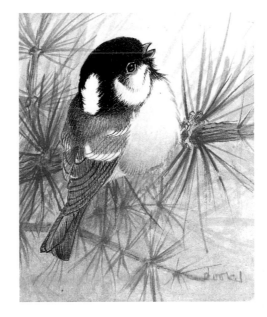

▲ **Coal Titmouse**
Watercolour pencils
7.5 x 6.5 cm (3 x 2½ in)
A combination of drawing and painting with Derwent watercolour pencils was used for this small picture, which incorporates some of the techniques described later in the book. The white areas are unpainted paper.

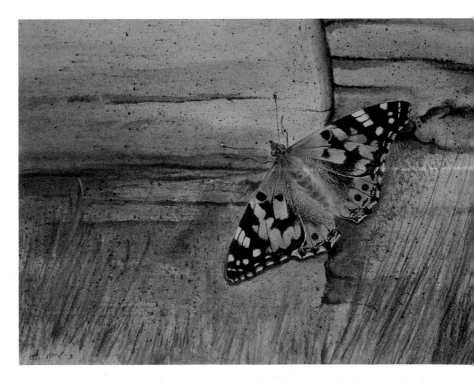

▲ **Painted Lady Butterfly**
Watercolour pencils
15 x 20.5 cm (6 x 8 in)
This butterfly is a detail taken from a painting made for demonstration purposes.

Materials and Equipment

Take every opportunity to try pencils new to you, especially at art materials shows. Experimentation equals illumination.

Coloured pencils and crayons

Coloured pencils are produced in round and hexagonal shapes. They can be blended, lightened, darkened and burnished, but increasing ranges of up to 120 colours lessen the need to blend for shades, variations or variety. As they do not dissolve, they are normally kept for 'colouring' in line or tone. Schwan Stabilo provide a solvent for their coloured pencils for painterly results.

Very waxy pencils can be similar in range to traditional coloured ones, but may be soft enough to smudge slightly. Others, such as Derwent Drawing, are limited to variations of brown. Often these have a thicker strip than normal pencils and are made in round and flat shapes. The latter are called carpenter's pencils.

▲ My workbox displays a limited selection of water-colour pencils from the full range of 72. Included are carpenter's, waxy, charcoal and graphite pencils with one or two coloured pencils used for demonstration purposes.

Oil-based crayons are normally in stick rather than pencil form, and are available in many colours. They are soft enough to smudge and can be used with stencils or for wax resist.

Pastel pencils

Round in barrel shape, with a thicker strip, these tend to be harder than 'normal' soft pastel sticks. Pastel pencils are more controllable, less messy, can give fine detail and smudge well. They are ideal for spontaneous painting. Pastels mix well with charcoal and some are soluble with water.

◄ Coloured pencils: dry linear and tonal marks.

► Waxy pencils: linear and tonal marks with frottage of wood grain.

◄ Pastel pencils: dry linear and tonal marks smudged with water.

Aquarelle, watercolour and water-soluble pencils

These are versatile and economical, with many makes and colour ranges to choose from. Not all 'watercolour' pencils are totally water soluble. Some could be more accurately described as 'soluble with water'. The dry colour of a water-soluble pencil can be completely washed out, whereas the dry colour of those 'soluble with water' cannot. This might seem too fine a distinction to make, but it is frustrating when drawn, dry

◀ Watercolour pencils: linear and tonal marks diluted and blended with water.

colour cannot be totally washed out, or a wash is bespattered with undissolved granules of pigment. Deliberate granulation – that is quite another technique (see page 37).

Some watercolour pencils contain Titanium White, so their strength of colour can be gouache-like if they are used heavily or dipped in water and used as a painting pencil.

Charcoal pencils

These can vary in their blackness according to their grade, often limited to three and described as hard, normal and soft, or light,

◀ Charcoal pencils: linear and tonal marks smudged and diluted with water.

medium and dark. Naturally softer, they smudge easily yet pressure can vary their tone from a hazy grey to a dense black. Charcoal pencils are usually round in shape and are good for sketching and sfumato, a technique described on page 23. Some are soluble with water.

Graphite pencils

These are so familiar that they are virtually disregarded, yet some artists can produce incredibly beautiful and detailed pictures using just graphite pencils. Twenty grades are available, ranging from 9H which gives a crisp, pale grey line to 9B which produces a soft, dense, black tone. In the middle of the range comes HB.

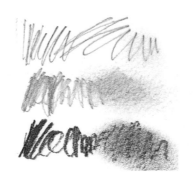

◀ Graphite pencils: three grades – 2H, HB and 6B – drawn and smudged where possible.

Water-soluble graphite pencils

Being water-soluble, these graphite pencils can be successfully included in paintings. The Derwent 8B Dark Wash is an indispensable pencil. Unlike some other water-soluble pencils, which contain lamp black, Derwent are pure graphite, so neutral tones can vary from a subtle haze to a thunderous darkness.

◀ Water-soluble graphite pencils: linear and tonal marks smudged and diluted with water.

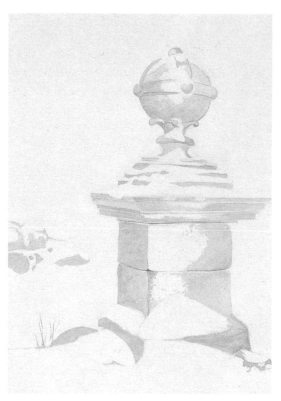

Paper

Reams can be, and have been, written on paper! The surface of a paper can influence the drawing or painting that results. A rule of thumb is that harder strips of coloured pencils or grades of graphite pencils need a harder, smoother paper surface. Crumbly or softer pencils, like pastels or charcoal, deserve a paper with more tooth, like Ingres which is traditionally used. Working with a hard pencil on a soft paper could tear it, or impress an image that is difficult to correct.

Paper is available in spiral-bound pads, blocks, on board and in sheets. These can be international in size, from A0 to A6, or handmade with names like Imperial or Royal. Weights vary from 96 gsm (45 lb) to 638 gsm (300 lb). The most popular is 300 gsm (140 lb).

Watercolour paper

Watercolour paper comes in three surfaces. Smooth, or Hot Pressed, is ideal for delicate, finely detailed work. Not, or Cold Pressed, and Rough are best when using coloured pencils with solvents or water for looser or

◀ **Misty Snow**
Watercolour pencils
30.5 x 24 cm (12 x 9½ in)
The coloured Bockingford paper used for this watercolour picture is left showing to define the snow.

impressionistic painting, as the paper's surface enhances the results.

Lightweight watercolour paper needs to be stretched to avoid cockling when made very wet. Use a slightly smaller piece of thin paper to lay beneath it to prevent it sticking to the board. Soak both pieces in water for a few minutes. Lift the thin sheet out first, drain it from one corner and smooth it on to the board. Do the same with the watercolour paper. Pat away most of the moisture with an old dry towel. Wet some 5 cm (2 in) brown paper tape and smooth it along the edges of the paper so that it overlaps them by 2.5 cm (1 in). Pat off any excess water from the tape and stand the board to dry overnight.

Other papers

Look for unusual papers such as imports from India and the Far East or handmade sheets impressed with or containing the flowers and grasses from which

▲ This selection of papers suitable for coloured pencil work includes watercolour paper, Ingres paper and various toned and textured papers, as well as a watercolour sketchbook.

▼ **Young Zebra**
Coloured pencil
28 x 28 cm (11 x 11 in)
The zebra was drawn in Derwent coloured pencil on a textured paper. The stippled surface breaks up the solid tone, adding interest to the zebra's markings.

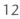

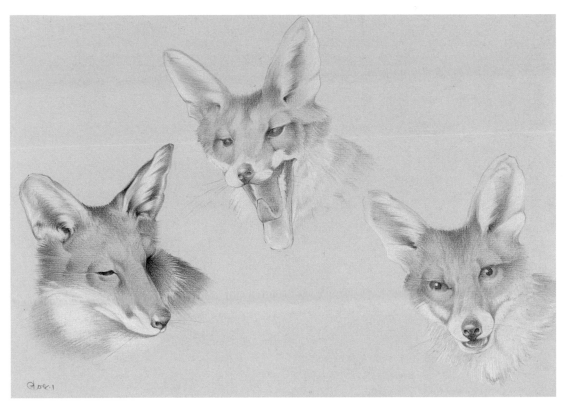

◄ **Fox Studies**
Watercolour pencils
28 x 39.5 cm (11 x 15½ in)
These animal studies were drawn dry on toned paper with Caran d'Ache watercolour pencils.

they are made. But be cautious of some cheaper coloured papers which may fade eventually. Alternatively, use pastel paper, other deliberately textured papers or a calligraphy pad of parchment-style paper.

When laying thin paper under your watercolour paper for stretching, beware of using newspaper as the print might transfer on to the underside. With lightweight watercolour paper, the newsprint might even show through.

▶ **Grey Heron**
Mixed media
30.5 x 20.5 cm (12 x 8 in)
Toned Keaykolour textured paper was used for this ink drawing with watercolour pencils used dry and wet.

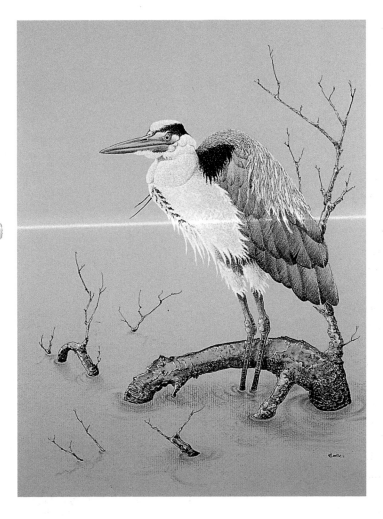

13

Whenever you buy a
round brush, ask to test it first.
Dip the hairs into clean water
and shake the brush.
The hairs should come naturally
to a point.

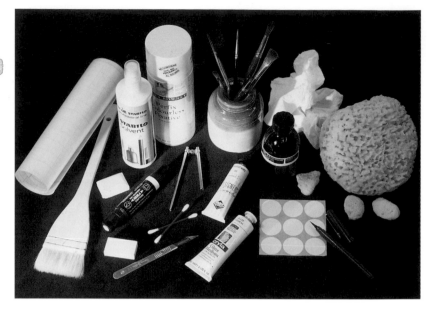

Brushes

The simplest advice is to buy the best you can afford. Kolinsky sable brushes are wonderful – and expensive! Manmade imitations like Dalon are popular and more economical. You will be amazed at the variety of brushes available. Start simply with three. A round No. 2 or 3, a round No. 8 or 10, and a flat 12 mm (½ in) or 25 mm (1 in) will suffice. Later add a rigger for fine lines and winter trees and perhaps a hake for broad and bold applications of paint. Initially avoid No. 0 or 000 rounds, unless you like to fiddle with minute detail.

▲ Some additional equipment such as masking film, sticky labels and solvents will add to the versatility of your coloured pencils, and brushes, sponges, erasers and cotton buds also help with creating specific effects. Other media such as gouache and ink can be successfully used in combination with coloured pencils.

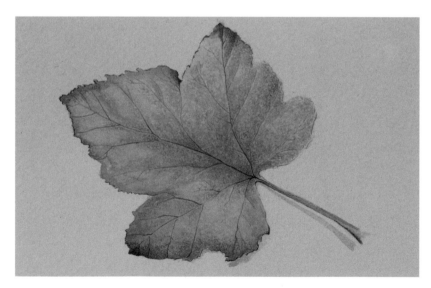

▲ Leaf Study
Watercolour pencils
10 x 12.5 cm (4 x 5 in)
A brush was used to blend parts of this leaf, drawn and painted in Derwent watercolour pencils.

Try using a piece
of soft bread – not the crust! –
for erasing marks or
softening tone.

Erasers

Erasers are not used in this book for correcting mistakes! As a 'drawing' aid, however, they are as useful as the pencils themselves. They are most successful used with graphite, charcoal and pastel pencils, but coloured pencils can benefit from the techniques of lifting out, cutting in or highlighting with a plastic eraser (see page 24).This can be cut into shaped pieces or slivers for controlled erasure. Graphite and coloured pencils can also be blended and smudged with a putty or kneadable eraser, but take care to clean it on a scrap of paper between colours.

Like pencils, soft erasers work best on soft, textured paper and hard erasers on smooth, or hot-pressed, paper.

Stencils, masking film and fluid

Stencils, masking film or fluid can be used to protect areas of white paper or to retain colour in a precise area. You can cut your own stencils from card or tear them from paper for a casual, irregular effect.

Masking film enables large areas of paper or a painting to be protected. It comes in two surfaces – gloss and matt. Unlike the gloss, the matt surface can be drawn on with pencil or ink. The best way of using it is to draw a design on to the film and cut it out with the backing paper still attached. You can then remove the backing and smooth the film on to the paper.

Consider ordinary sticky labels for masking, too. Particularly useful are round ones, shaped ones like stars, or square and rectangular ones for geometric designs.

Masking fluid is ideal when small or detailed areas of paper or a painting need to be reserved. Apply it with cocktail sticks or cotton buds. If you use a brush, it should be one you are prepared to sacrifice, because even with vigorous cleaning the brush could be ruined.

Solvents

Solvents for use with crayons and pencils are available in a spray can or in handy double-ended blenders which are normally alcohol based. But you introduce a toxic agent with solvents, so don't suck the pencil points!

Particles of non-soluble pencils can be cut into a container and sprayed with solvent. This can be applied like paint, using a brush or a cotton bud. For a textured effect, scrape shavings of non-soluble pencils or crayons on to dry paper, then dissolve or move around with a cotton bud soaked in solvent.

Additional equipment

A practical addition is a board to clip or fix paper to for support. Also useful are small pieces of a natural sponge, for special effects as well as for lightening paint or correcting accidents. Kitchen towel is helpful not only for mopping up but for lifting out cloud shapes from a still wet sky. It works much like the sponge, but can be far more absorbent. Folded and twisted kitchen towel makes a simple tortillon (a stump of compressed paper), useful for smudging and blending as are cotton buds.

A craft knife or a scalpel will come in handy, not only to sharpen the pencils, but for scratching out highlights and for some of the techniques described later in the book. Try to avoid 'snap-off' blades as, if used under great pressure, the blade does just that.

If you plan to use a lot of pastels, charcoal or pure graphite pencils, you will need an aerosol or spray can of fixative to prevent smudges. Alternatively buy a bottle of fixative and blow it through a diffuser.

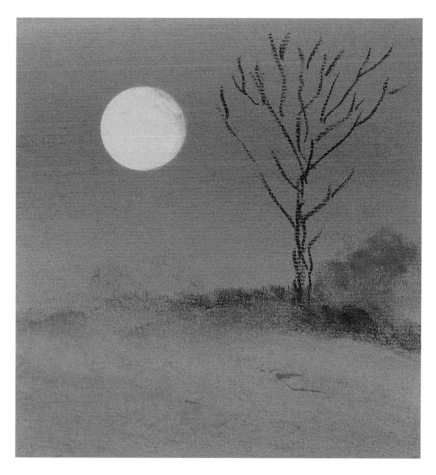

▲ **Sunset with Tree**
Pastel
20.5 x 20.5 cm (8 x 8 in)
Yellow pastel dust was smudged with tissue on Ingres paper and protected with a round sticky label as a mask. Red pastel dust was then rubbed in. Removing the mask revealed the yellow sun.

Making a Start

The barrel shape of a pencil can predetermine how it is held, and this in turn affects how it feels and the quality of mark that is made. Try the following exercise to see for yourself.

Holding a pencil

Take a round and a hexagonal coloured pencil of identical colour, preferably made by the same manufacturer – for example, a Derwent Artists and a Derwent Studio – and make linear and tonal marks with both. Is one harder than the other? Are they the same? Probably the round pencil 'feels' softer than the hexagonal. It gives broader marks and an even tone is easier to block in. The hexagonal pencil gives finer, crisper lines suitable for detailed drawing.

How did you hold the pencil? Often a round one is laid in the palm of the hand and grasped to draw and tone with, whereas a hexagonal pencil is held upright, between the thumb and the first two fingers, like a pen. Both positions are automatic. So, too, is revolving the pencil in use. Round pencils

can be moved freely in either direction, rotated halfway round, even revolved a couple of times. Every movement is an unconscious action to achieve and maintain an even stroke or tone.

The hexagonal pencil's shape dictates that for comfort's sake the flat surfaces are held against the thumb and fingers in an upright, triangular grip, giving a finer line. Because it has six sides, when the pencil is rotated, a comfortable turn is at least 60 degrees. This, scientists claim, is the minimum turn needed to maintain a sharp point on the pencil.

The finer line suggests that hexagonal pencils are 'harder' than round ones. Actually, in the case of the two Derwent pencils, the density – the hardness or softness – of the two strips is identical. So, choose round pencils for looser, broader, expressive use and hexagonal ones for crisper, detailed, graphic, even technical, illustration. There is a place for both, even within a single picture.

▲ Cut-away sections show how both hexagonal and round pencils have the core or strip sandwiched between two pieces of cedar wood that form the barrel.

◄ An almost horizontal hold is adopted for a round pencil.

► A hexagonal pencil is held between the thumb and two forefingers.

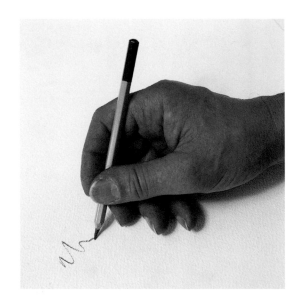

As for the flat carpenter's pencil, this can be held in either way. The broad and narrow edges of the strip give a natural, calligraphic blend of thick and thin on the paper. The pencil can also create broader applications of tone as in frottage (see page 22).

Sharpening a pencil

Most pencils, especially those purchased in sets, are pre-sharpened ready for use. During manufacture they are sharpened on a swiftly rotating band of sandpaper. Pencil sharpeners give this neat appearance to the point but no variety to the point's shape. Such sharpeners can cause the strip to fracture if hard, or crumble if very soft.

Imagine yourself as a pencil. Suddenly your head is wrenched to one side! You would get a headache, if not a broken neck or fractured spine. A pencil strip is glued and sandwiched between two pieces of wood, so inserting the end of it into a sharpener and twisting is similar to your head being forced around on top of your body. Pressure exerted rotates downward and can cause fracturing.

Preferably sharpen all pencils by hand with a sharp craft knife or scalpel – you have to with the flat ones anyway! Pressure is then carried along the length of the pencil and a fracture of the strip is less likely to occur. If you were the pencil you might get a sore ear;

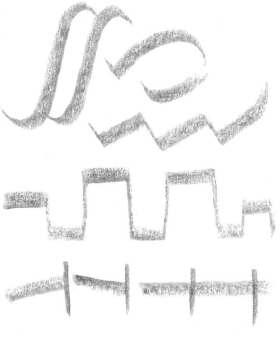

◀ Both thick and thin calligraphic marks are possible with a flat carpenter's pencil.

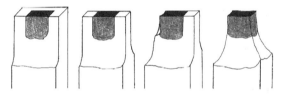

◀ Carpenter's pencils should be sharpened with a knife or scalpel, starting with a broad side. The opposite broad side is cut next. The shoulders of the thin sides support the core and prevent accidental breakage. The two narrow sides are then cut.

but even if you lost an ear, just think of the price of a Van Gogh painting nowadays!

By using a knife or sharp blade, a variety of points can be fashioned and used. Once a pencil has been sharpened, it can be rubbed on fine sandpaper or glass-paper during use to retain the shape and point.

◀ Round and hexagonal pencils were held horizontally and upright to record this sketch done on location.

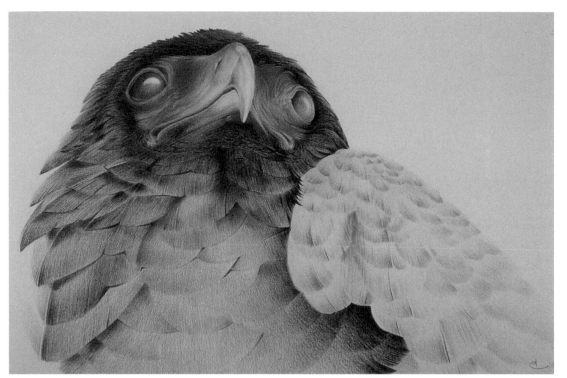

◄ **Bateleur Eagle**
Coloured pencils
20.5 x 30.5 cm (8 x 12 in)
This bird study illustrates
negative and positive
drawing done on a mid-
toned paper.

Making a mark

Marks made with pencils are linear or tonal,
and positive or negative. In positive drawing,
dark marks are made on light or white paper,
whilst in negative drawing light marks are
made on a dark or toned surface. Both are
used in *Bateleur Eagle* (above).

Lines and dots

All pencils give a thin or thick line when
drawn across paper. The thickness depends
on the grade (hardness or softness) of the
pencil and the angle at which it is held. If held
upright, a pencil gives a thin stroke, whilst if
angled to the paper it gives a broader stroke.

Varying the pressure will affect the quality
of mark made. Putting more pressure on a
pencil thickens a line. Short stabbing marks,
too, will have a denser tone if more pressure is
exerted. On the other hand, rolling the tip of a
pencil lightly across the paper gives a random
line or scumbled, broken colour.

Straight or curved, lines indicate direction.
The length of a line can express movement.
Short, sharp lines imply speed, while long
undulating lines drift and flow languorously.

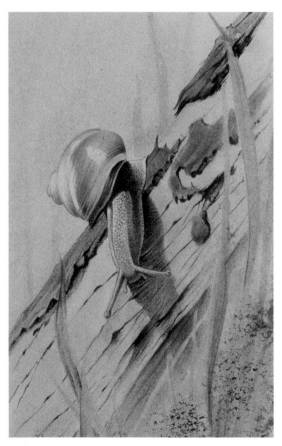

◄ **Heath Snail**
Mixed media
A detail from an original
measuring 15 x 7.5 cm
(6 x 3 in) contains dots
and lines, both drawn and
painted with Derwent
watercolour pencils and
Cryla acrylic paint.

Differing dots of colour or tone result
when a pencil point is dabbed at the paper.
Hard pencils give pin points, while soft

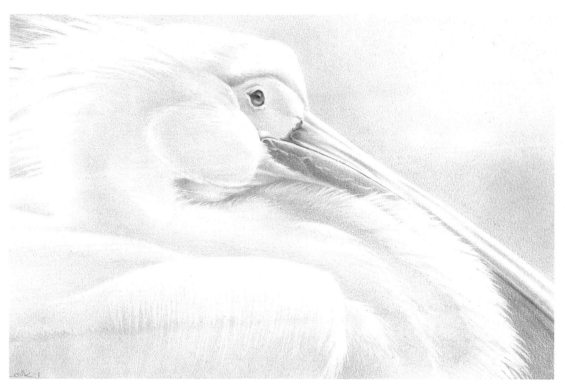

◄ **Pelican Abstract**
Sfumato in graphite
20.5 x 30.5 cm (8 x 12 in)
Graphite dust was
smudged on the paper
with a finger, then
blended and lightened
with an eraser. The darker
tones were carefully
drawn in with graphite.

pencils give definite dots. If the pencil point is
rotated into the paper, a broader, miniature
disc of colour or tone is achieved. Rotate the
flat point of a carpenter's pencil for a larger
spot or disc.

The closer dots or lines are placed together,
the deeper the colours and tone that appear.
Mix different coloured dots and lines together
for optical blending. Combine dots and line
to give comma-like marks for variation.

Techniques using different kinds of marks
include hatching, feathering, stippling and
pointillism. These and others are explained in
the Basic Techniques chapter which follows.

Strokes and bands

To make strokes the pencil should be held in
the palm and as flat to the surface of the paper
as possible. Strokes become bands of colour
depending on how much of the pigment strip
has been exposed when sharpening the
pencil. Flat carpenter's pencils give a wider
band of colour in a single stroke. But for the
broadest marks, crayons and similar sticks of
colour – pastel, charcoal or graphite – used
flat against the paper will give expansive
sweeps of colour or tone.

Tonal marks

Smudging with a finger, tortillon or eraser
will give tonal marks, as will rubbing in
particles of crumbly pencils like pastel or
charcoal. Tone can be enhanced by
burnishing, softened by lifting out and
highlighted by cutting in. These methods are
enlarged on in the next two chapters.

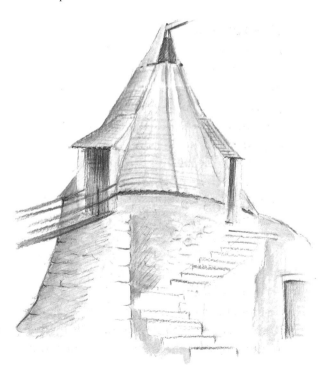

► Using watercolour
pencils and soluble
graphite, the drawn
strokes and bands of this
sketch were softened with
a damp brush.

19

Basic Techniques

Most of the techniques described in this chapter are traditional, but others have been devised to increase the versatility of pencils and crayons. The images have been deliberately kept simple, but the techniques can be adapted for all levels of ability.

Dry techniques

These techniques can be carried out with all types of pencil and ordinary or oil-based crayons. The first five use linear marks to achieve form and to indicate direction when drawing. The rest are tonal, producing areas of light and dark colour in a variety of different ways.

Hatching and crosshatching

In hatching, lines or strokes are usually drawn straight and parallel to each other. This gives a flat tone, dark or light depending on the closeness of the lines to each other. If you draw the lines in a fan shape, those closer at one end will be darker compared to the more open lines, and the tone will shade from dark to light. In this way you can build up tonal variation. Straight lines can also indicate curvature as seen in the illustration of the cylinder.

In crosshatching, the lines are crossed with more straight lines and the tone darkens. By

mixing colours and changing the angle of the crossing lines as well as by adding others in different directions, you can affect the tonal contrast and colours of the marks made. This is shown in the cube and its shadow.

Contour and bracelet

These techniques are similar to hatching, but the curved lines convey direction and better express the 'form' of the object being drawn. Although a shell and branches are shown, you can adapt the technique to any rounded subject, be it a nude or a building.

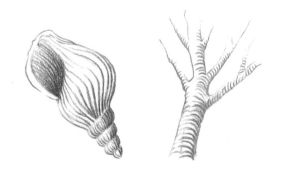

◄ Contour shading on the shell helps define its form. Bracelet shading on the tree has the same effect.

Stippling and pointillism

Dots are used instead of lines, giving an atmospheric appearance to any drawing. Density and curvature are indicated by the placement of the dots to each other, as with lines. Stippling normally implies minute dots, whilst pointillism relies on larger spots. This is illustrated in the orange.

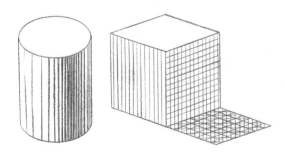

▲ Depending on the closeness of line, parallel hatching can indicate the roundness of the cylinder.

Hatching and cross-hatching indicate the tonal differences on the cube and its shadow.

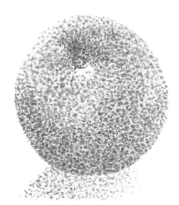

◄ Depending on the density and size of the dots, stippling and pointillism give shape to the orange.

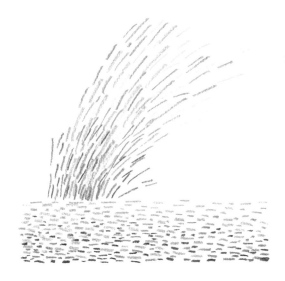

◄ Broken line in the water and feathering of the reeds indicate movement and direction.

Put small patches of each technique on to paper. Repeat on thin tracing paper and place over the first paper. Rotate and mix the tracings to discover a multitude of possibilities – especially when mixing colours.

Broken line and feathering

These are variations on lines and strokes. Broken line implies short and multidirectional marks made randomly and varied in pressure if you wish. You can add variety by mixing colours. Feathering also uses short lines, although these can be varied in length or curved. They are usually laid in the same direction.

Gradation and shading

These techniques border on tonal application, depending on how closely the lines of colour are laid together. By increasing the pressure on your pencil, the density of colour progresses from light to deep. This is the basis of gradation, which is invariably done with

straight lines, while shading can be directional and curved to indicate a change in plane or form. In the illustration below, the sun and water are shaded whilst the background sky is gradated.

Blending and soft blending

In gradation a single colour is stroked across the paper with increasing pressure from the lightest tint to the deepest hue. In blending, two or more colours are laid over each other. Choose a colour and draw two bands of this colour – one lightly, the other as heavily as possible. Using another colour and starting halfway along the coloured bands, blend the colours using the same pressures as before.

▼ The two strips show the effect of the same two colours blended heavily and lightly into each other. The block of primary colours smudged into each other reveals the three colours of orange, violet and green.

▲ Gradation in the sky and shading in the sun alter density, tone and colour by creating additional colours to the basic ones used.

Try blending the three primaries together starting with yellow, then red and finally blue. Reverse the procedure. Which colours dominate? Oil-based crayons will give a wider band when blended, as they are softer and more smudgeable than coloured pencils.

▲ Dark colours can be built up over lighter ones and new colours created. This depth or density of colour enables sgraffito – scratching through – to reveal the colour underneath.

▲ Both graphite and colour rubbed over impressed lines and squiggles formed with the prongs of a fork show them as lighter tones. Experiment with several colours used together.

▲ The frottage from a plank of wood. If turned on its side, the grain resembles rippling water.

Building up and sgraffito

Building up or layering colour is when several layers of the same or different colours are placed over each other. Start with pairs of different colours, then reverse them. Increase the number of colours used over each other. Underlying colours affect those on top and vice versa, depending on the predominant colour. Only by experimentation will you discover the immense number of hues that can be obtained by laying colour over colour.

Sgraffito is an extension of this principle. Lay two or more layers of colour over each other. With a scalpel, craft knife, scissors, even a pin, scrape or scratch through the top layer to reveal the colours underneath. This technique is well known in the tiles and ceramics industry.

Impressing and frottage

Impressing and frottage are reversals of the same application. Impressing gives fine lines within an area of tone. Place a sheet of paper on a pad of soft paper such as kitchen towel or newspaper, then indent (impress) with your thumb-nail, a brush handle, or a knitting or darning needle. Do not cut through the paper. When you draw colour over the paper, the impressed lines are revealed against the colour used. This technique is excellent for fine whiskers, barbed wire or the rigging on boats.

When impressing, note the difference between using dry and wet colour. If a wash is

▶ A web was impressed on to Not paper through thin tracing paper. A mix of coloured pencils covered the background to reveal the white web.

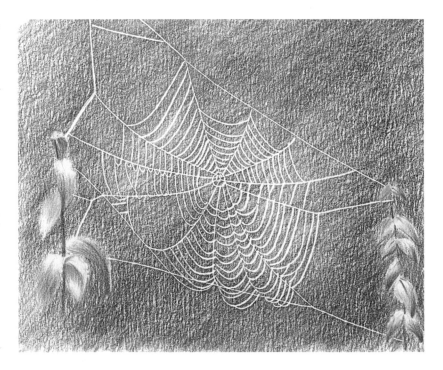

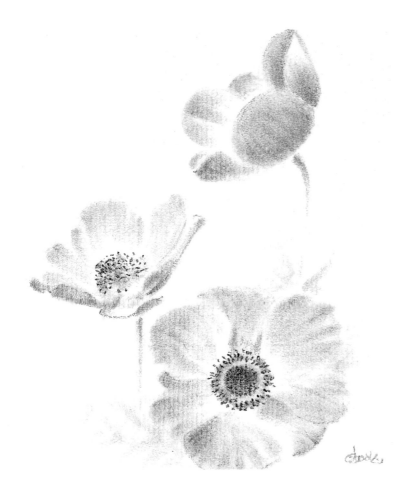

Sfumato

Originally sfumato, an Italian term, referred to coating a piece of paper evenly by holding it over a smoking candle. The resulting sooty deposit was drawn into with bread to make light tones, while handmade charcoal created the dark tones. Leonardo da Vinci is thought to have used this technique.

Nowadays sfumato can be simplified by scraping particles of charcoal or coloured pastel pencils on to paper and rubbing them in with your hand, a paper towel or a dry tissue.

Sfumato's limitation to three basic tones is a good discipline. Simplicity is its attraction, lack of contrast its only apparent failing. However, where soft results are required, this is an advantage.

laid over impressed paper, it usually runs into the depressions to give a darker tone.

For frottage, lay thin paper – 90 to 100 gsm (42 to 47 lb) – or Ingres paper over a textured surface such as wood grain, a drain cover or grating, rough sandpaper, even the seat of a wicker chair. Then rub oil-based crayons, pastel pencils or a soft graphite pencil (6B or more) over the paper to record the underlying texture. For pointillism or broken colour effects, lay the paper over a cheese grater and move it slightly between each application of a different colour.

Smudging

This is often learnt by accident! But when it is used deliberately, drawings take on a painterly effect. As well as using your fingers, you can exploit smudging with erasers and cotton buds, or control it with tortillons, brushes, even cocktail sticks. Lines and areas of tone can be smudged, with oil-based crayons and pastel pencils being especially successful.

▲ Pastel dust was smudged with a cotton bud to give the delicate colours of the anemones.

▶ The candle in this sfumato was erased by hand, while the central flame was lifted out through a cut stencil.

Burnishing

Burnishing, usually with a white or light-toned crayon or bone-handled knife, lightens the colour burnished. When burnishing with the back of the bowl of a spoon, darker – sometimes metallic – hues are possible. The only cautionary note is that heavy burnishing may result in wax bloom. Excess pressure can cause the wax in coloured pencils to glaze with a greyish tint and dull the colour. Rubbing with a tissue or paper towel should remove it. To prevent its recurrence, spray with fixative straight away.

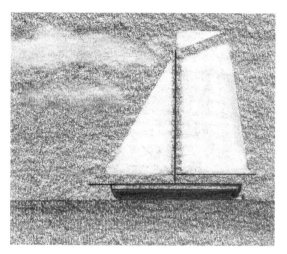

◄ I toned the paper with graphite pencil. The clouds were lifted out with a soft eraser and the sails cut in with the eraser through a cut stencil.

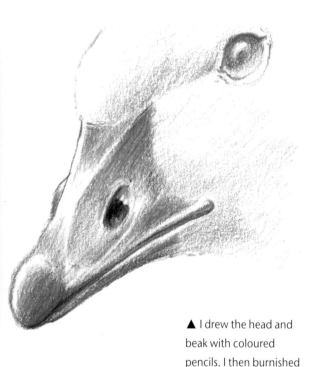

▲ I drew the head and beak with coloured pencils. I then burnished the beak with a white coloured pencil to give the bony effect.

Lifting out and cutting in

You will need an eraser for these techniques. By using a putty, kneadable or standard eraser freehand, you can lift out or lighten tone or colour. A crisper, cleaner image or predetermined shape can be cut in with a plastic eraser using a template or stencil. These can be purchased, or you can cut and tear your own from stiff paper of 300 gsm

(140 lb) or thin card. Alternatively, use masking film or self-adhesive labels and shapes to protect an area to be left toned or coloured.

Water-soluble techniques

While water-soluble pencils can be used dry like any other pencil, water extends their versatility, enabling you to achieve effects similar to watercolour or gouache painting. When mixed with other types of pencil, unlimited exciting possibilities arise.

Trying the techniques

Most of these wet techniques can be used with totally or partially soluble pencils. Try them with all the water-soluble pencils you possess. While you are experimenting, use cartridge or other inexpensive paper. And don't be afraid to use the back to avoid wastage. I even tape pencils ends together when one becomes too small to hold. A lot of paintings are inside a small stub.

There are three generally accepted ways of using water-soluble pencils: dry on dry; dry into wet; and wet into wet. Try these for yourself with this simple exercise. With a single water-soluble pencil draw a patch of colour about 7.5 × 5 cm (3 × 2 in) in size. Wet a brush and turn the patch into a washed tone. While it is still wet, draw two simplified trees into the wet wash using the same pencil. Now dip the point of the pencil into water and

▼ The dry background tone which I then wetted is lighter than the trees which were drawn into the wet tone. The person is darker still for being drawn wet.

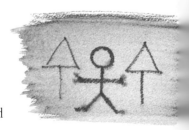

24

draw a matchstick person between the two trees. As in the example shown, you will notice that the person is darker in tone than the trees, which in turn are darker than the background wash. This clearly shows how the three applications affect the result. It also very simply illustrates the principle of aerial perspective: the tones diminish as they recede (see page 41).

From drawing to painting

When working towards a painting, it is best to draw with the pencils first, then carefully spread the colour with a clean wet brush – a technique reminiscent of the 'magic colouring books' of long ago. Dipping pencils into water and trying to paint with them is not advocated unless you want to ruin the pencils. So dunk sparingly, and dry the pencil on tissue or paper towel straight away.

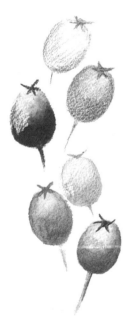

◄ This illustration of rose hips shows the progression from a dry drawn image to an image toned with a wet brush. To avoid a heavy result like the third rose hip from the top, apply the pigment with a light touch.

The illustration of rose hips shows how dry drawn images can be developed into a watercolour painting. The top drawing is sketchy and dry. More detail has been added to the second one, which could be considered a finished drawing. However, beware of applying too much dry pigment at this stage as a gouache-like density can result when water is added, as shown by the third rose hip. This is a common fault. If you want a

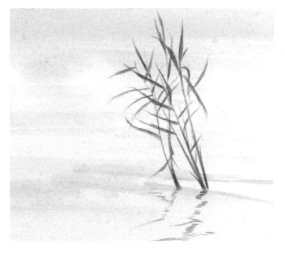

◄ I drew these reeds in watercolour pencils over a blended watercolour wash, adding reflections in dry drawing. The ripples were drawn dry and softened with a wet brush.

watercolour effect, it is best not to be too heavy-handed. The three lower rose hips were toned with a wet brush and built up with extra colour to the finished painting.

▼ Several years ago, I drew these gannets dry with Aquarelle pencils on a toned paper. I could still paint the images with a wet brush if I wished.

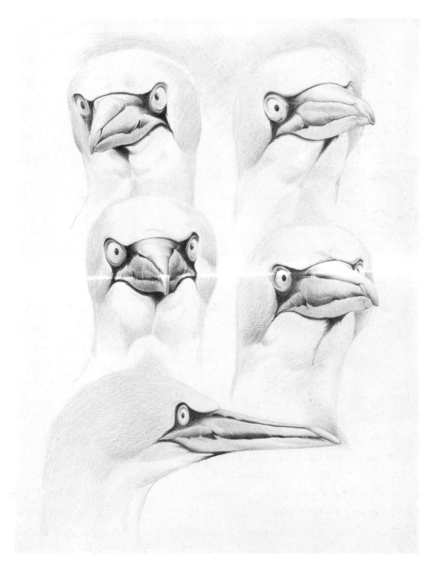

Applying colour with a brush

When you want extra density or a deep colour, as in the painting of the autumn leaf below, use the tip of a wet brush to lift off dense colour from the tip of a water-soluble pencil and apply it to the painting. The advantage of this method is that the colour is easily correctable with a wet brush. This is preferable to drawing into the wet paper or dipping the pencil into water – both will certainly give a strong colour, but one that is virtually impossible to remove.

▲ Scribbles drawn with a wet pencil (top) and into wet paper (bottom).

▲ Scribble made from dense pigment taken from the tip of a pencil.

Look at the scribbled examples. Those drawn with a wet pencil or drawn dry on to wet paper cannot be removed even by scrubbing a brush over part of them, whereas the scribble painted with dense colour taken from the tip of the pencil can be almost completely removed. So these coloured soluble pencils are not only flexible and versatile, but controllable.

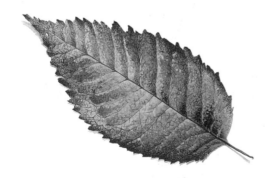

▲ The deepest colour on this leaf was taken from the tip of the watercolour pencil, while blended colours were taken from a paper palette.

Paper palette

Red drawn over yellow or vice versa will give orange when wetted, but the exact shade will depend on the pressure applied with each pencil, and in what order. Sometimes, the last colour used dominates. Naturally this can be disappointing, but you can overcome the uncertainty by using a paper palette.

To work in this way, rub patches of the colours you wish to use on to a scrap of watercolour paper. Touch these dry patches with a wet brush, lifting the colour for direct use or for blending with another colour patch. Not only do you achieve the exact shade of colour you require, but also the correct density.

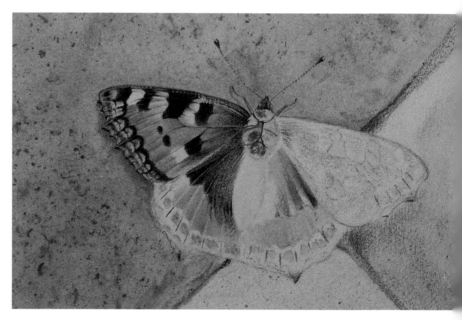

The tortoiseshell butterfly detail in the painting above shows the various stages I went through to achieve the completed image. The butterfly was first drawn on to the paper with dry watercolour pencils, as shown on the top right wing. The right underwing was then wetted and the colour blended. The completed left forewing and underwing were painted from colour patches on a paper palette.

Note how the colours have been built up to achieve a gouache-like opacity. As the exact colour blends were obtained before use, they were perfected before application.

▲ **Tortoiseshell Butterfly**
Watercolour pencils
15 x 20.5 cm (6 x 8 in)
This detail was taken from a demonstration painting.

▲ I made this study of a young horned eagle owl in a watercolour sketchbook by drawing direct and using the paper palette scribbled down the right-hand side of the sheet.

When on location, a paper palette avoids risk of losing pencils. Rub squares of your chosen colours – try a limited selection of Burnt Umber, Ultramarine and Cadmium Yellow – across the short edge of a sheet of A5 watercolour paper. This, with a brush and water, will enable you to make quick colour notes or small paintings *in situ*. As the colours are exhausted, rub on extra pigment.

Spattering

Water-soluble pencils are a cleaner way of spattering colour than the usual method of using a toothbrush or brush loaded with paint. Use a long point – exposing about 2.5 cm (1 in) of pigment – for this technique to prevent the wood of the pencil getting too wet.

Note the beach beneath the sky (above right). Just flick a wet brush across the tip of a pencil, downwards towards the paper. Mix colours, either when the first has dried or wet-into-wet. It is worth experimenting with

different shapes and sizes of brushes: each gives its own result, even flat brushes, wide or edge on. Try it! With a little practice, you will be able to flick off just a spot or two of colour into a chosen area. The spontaneous result is far more pleasing than an obvious attempt to be casual.

Spattering can be controlled, as in the example of the moon in a night sky (below), or contained, as for the sun. In both cases a sticky label was used as a mask to protect the white paper and the pale blue sky.

▲ I spattered the paint on to dry and wetted paper for the beach effect.

▼ I used sticky label masks to create the moon and the sun.

27

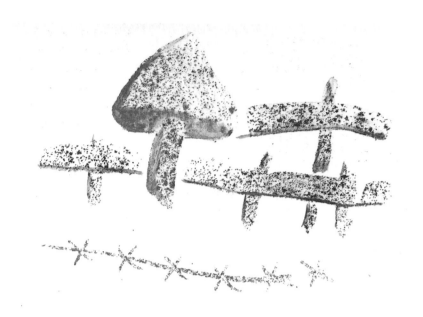

Textural effects

To create a textural effect on a specific shape, you can adapt the technique used for a large wash (see page 30). For the mushroom, a squat arrow shape was painted in clean water. Raw Umber pigment was scraped into this and, while still wet, the dissolving particles on the underside of the arrow shape were disturbed with a brush to tone beneath the mushroom cap. The brush was then stroked down one side of the cap and stalk.

Any shapes, even fine lines like the broken fence and barbed wire, are possible. A mix of

▲ I pre-wetted areas of paper in a defined way and scraped pigment into them to reveal the images shown.

▼ The same technique as above can build both regular brick and random stone walls.

colours, including graphite and charcoal, can be used to create regular brick, or random dry stone walls. Blow away the unwanted pigment from the dry areas. Simple!

To indicate grass, drop a mix of several greens, blues and yellows into a puddle or stripe of clean water. Using a 12 mm (½ in) or 25 mm (1 in) flat brush (a Daler-Rowney D22 Dalon for instance), wet and splay the hairs apart slightly with your fingers and drag the mixed particles of pigment up into the dry area.

With control spiky fir tree leaves are possible, as in the painting *Coal Titmouse* on page 9. A mix of browns gives a realistic wood grain, a mix of blues simplified water as shown. For lichen, curl the particles or shavings by scraping the knife blade along the coloured core at a 90 degree angle, rather than the acute angle adopted when sharpening a pencil. Drop them on to dampened paper and leave well alone!

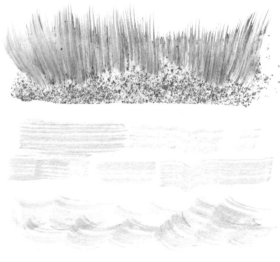

▲ I cut particles of dry colour into a wet area and teased them out with a splayed brush to produce grass. This method can be adapted to give wood grain or indicate water.

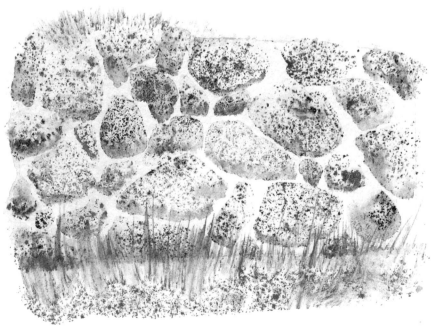

Using water-soluble graphite

Used alone, any of the earlier techniques are possible with this 8B pencil. It is interesting to compare it with an Ivory Black watercolour pencil when used with soluble coloured pencils, especially when water is added as in the birch trees. Some people see the colours blue, mauve or green in an Ivory Black wash.

By mixing soluble graphite with yellow, you will get a subtle green, quite unlike the definite green given by yellow mixed with Ivory Black. Mixing soluble graphite with other colours tones them down without altering the colour much. You can also mix soluble graphite with Ultramarine or Burnt Umber to improve granulation (see page 37).

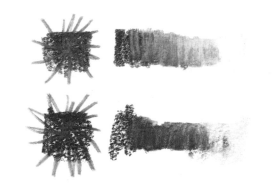

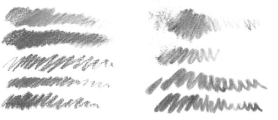

◀ Blue and yellow Schwan coloured pencils are spiked with the fine end of an alcohol-based blender and blended with the alternative broad end.

◀ The same pencils in different colours are toned with Stabilo solvent on a brush and with a cotton bud. They are also cut into solvent-soaked paper and smudged with a cotton bud.

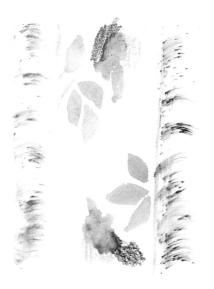

▲ The trunk markings show the difference between soluble graphite pencil (left) and Ivory Black watercolour pencil (right). By blending with yellow, green can be made for the leaves.

Solvents

Many solvents can be used to dissolve a non-soluble pencil – alcohol, acetone, lighter fuel, turpentine and white spirit among others. An element of risk accompanies these, to you more than to your paintings, so take care with them. Coloured and soluble pencils are non-toxic – as they are used by children, strict manufacturing regulations ensure that they have to be. Toxicity and a strong odour are introduced with solvents, so work in a well ventilated room.

Working methods

Schwan Stabilo produce a solvent in a pump action can. Drawings in non-soluble colours can be sprayed with this and the colour moved with a brush. Alternatively, you can draw on to a sprayed area of paper, but you will need to be quick as the solvent evaporates.

Another method is to spray some of the solvent into a small plastic or glass container. Either dip in a brush, cotton bud or twist of paper to paint over a drawn image, or dip in the point of the pencil for a strong colour to draw and 'paint' with.

Blending is more successful when colour is drawn dry and blended on the paper with a solvent and a brush. Convenient to take on location are alcohol-based blender sticks with a broad and a fine tip in the one marker. These give both casual and controlled areas of tone and lines, but their use is limited to blending on paper.

Solvents dry quickly and some areas may need to be reworked. Another consideration is that some may dull or muddy the colours and accidental transference of colour may occur if the blending stick is not cleaned between applications.

Innovative Techniques

There are many less obvious techniques I have discovered or invented while testing and using all types of pencils experimentally. These are interesting to try and will increase your scope considerably.

Using coloured dust

With a knife or scalpel, scrape particles of dust from any crumbly pencils, especially pastel or charcoal, on to your paper. Rub the particles evenly over the paper with a piece of paper towel or a tissue. You can use stencils or masking film before, or if using several colours, during each application of colour.

For details, I scrape a pile of coloured dust particles on to a separate sheet of paper, then pick up the dust on the pointed end of a tortillon twisted from paper towel and draw with it. You could do this with a cotton bud instead for a softer look. But for just a hint of colour, pick up the coloured dust on a dry round brush and 'paint' with it. Gentle, hazy tones will appear, excellent for subtle background images.

Making a large wash

To make a large wash with coloured or graphite water-soluble pencils, don't try the obvious by rubbing dry colour over the area and then wetting it. This is both time-consuming and unpredictable. Instead, reverse the procedure.

With a large brush – a Daler-Rowney S155 hake, for example – wash clean water over the area to be coloured. While it is still wet, use a scalpel to scrape small particles of pigment from the pencil tip on to the wetted paper as if you were sharpening the pencil. Dissolve these with a wet brush.

With practice, a large brush, plenty of water and a long point of pigment showing on the

▲ **Water Lily**
Pastel
15 x 28 cm (6 x 11 in)
I rubbed dust from pastel pencils into Ingres paper with paper towel, adding details with cotton buds and a tortillon.

▲ I made the Ultramarine Blue and Raw Sienna washes by scraping particles on to pre-wetted paper. I lightened the blue wash with dry tissue and streaked in the sienna with a dry brush.

pencil, a wash up to A2 size is possible before the paper starts to dry. Use a fine mist spray to keep the paper moist, if it begins to dry out.

Blending on a brush

On a dry piece of paper, rub down a patch of red pigment and near to it a patch of blue. Wet a flat 12 mm (½ in) brush and brush one corner of it on to the red patch. Twist the brush over and pick up blue on the other corner. Carefully

dip the point of a yellow pencil into water and stroke the wet point on to the middle of the brush from both sides. Let the colours blend a little, then holding the brush like a pen, strike an arc on the paper. You will get a simple rainbow. For a striped cloth or plaid effect, repeat the first steps but separate the hairs into three mini-brushes before painting.

▲ Blending several watercolour pencils on a flat or round brush gives multicoloured effects such as a rainbow, a plaid pattern and petals.

Soluble pencils allow precise positioning of colour on to any brush. Load a large round brush with one colour, then with a wetted soluble pencil add another colour to the tip of the brush. Gently lay the brush against the paper for dual-coloured petals.

Painting with a sponge

As well as lifting out colour, sponges can be used to paint with. For trees and foliage, scrape

◀ To suggest the leafy tree top, I collected dissolving watercolour particles from a pencil on a damp sponge and dabbed it on to the paper. When dry, I drew the trunk and branches in.

a mix of green particles from soluble pencils into a small puddle of clean water. Moisten the sponge and dab it into the dissolving pigment. Dab this on to the paper. Repeat as necessary until you have built up a tree or hedge. To vary the density, twist the sponge as you dab it into the pigment. Leave to dry. Small areas can be re-wetted and more green scrapings dropped in to represent leaves.

Coated paper

For an innovative effect on a background, try the coated paper technique. Coated paper has a shiny surface like the paper used for glossy magazines and can be bought from stationery shops. With Cryla or a similar acrylic paint, you can create incredibly detailed backgrounds for a painting. Dab a few colours of diluted acrylic at random on to a piece of coated paper and lay a second piece on top. Quickly rub the top paper to squeeze the paint between the two sheets, then pull the top sheet away. You should see a result rather like a piece of coral.

▲ **Buzzard's Bastion**
Mixed media
11.5 x 11.5 cm (4 ½ x 4 ½ in)
A mix of Cryla acrylic paint and Chromacolour was spread on a coated paper. This was then rubbed down and pulled away quickly. Once the intricate background had dried, the buzzard was painted on top.

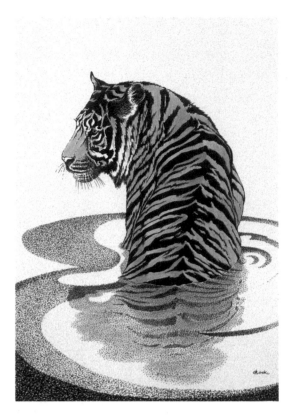

Scraperboard

This is usually purchased as a black surface into which white lines are incised with a knife or various scraperboard tools. However, for this idea you will need white scraperboard. Draw and paint on to the scraperboard with ink and scratch back to reveal fine white lines and detail. When you are satisfied with the black-and-white image, use water-soluble pencils or wax crayons to paint or draw colour on to it. When dry, this can also be scratched into for more detail. The painting *Tiger I* was done in this way.

Simulator or heavyweight tracing paper

Simulator is like heavyweight tracing paper and has been used for the paintings *Indian Elephants* and *Tiger II*. The paper can, with care, be scratched into like scraperboard and any lines drawn in graphite, coloured pencil, wax crayon or ink can be scratched through.

▲ Tiger I
Mixed media
20.5 x 15 cm (8 x 6 in)
This pen and ink drawing on white scraperboard uses lines and dots to express the image. A single watercolour pencil wash tones the animal.

▼ Tiger II
Mixed media
12.5 x 10 cm (5 x 4 in)
This second pen and ink drawing was done on heavyweight tracing paper. Colour was put on the reverse with dry watercolour pencils.

▼ Indian Elephants
Mixed media
10 x 15 cm (4 x 6 in)
The dry graphite drawing of elephants is enhanced with watercolour pencil used dry on the back of heavyweight tracing paper.

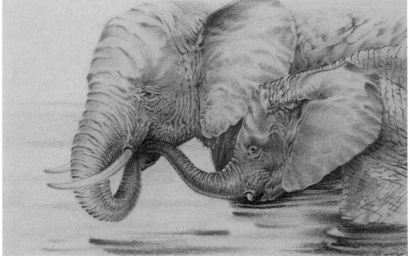

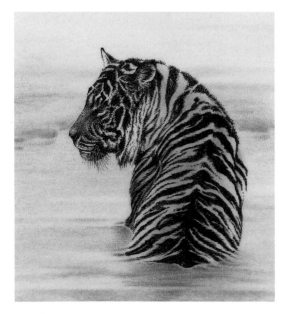

An innovative way of using this paper is to draw on one side and use colour on the reverse. The slight opacity of the paper softens the colour. You can scratch highlights into the colour or scratch through your first colour and then cover it with other colours that will show through the scratched areas. Rather like sgraffito – in reverse!

Transferring a design

If you need to transfer a design to a final artwork, make a transfer sheet with watercolour pencil instead of the more usual method of rubbing graphite over the back of the design. Cover one side of thin paper with Raw Umber used dry. Place this coloured side down on the art paper and on top lay the design to be traced through. If you make a mistake, instead of rubbing out graphite and possibly spoiling the paper's surface, use a damp brush to wash away any error without damage. The umber will not stain the paper.

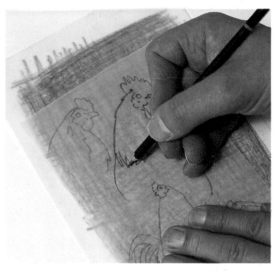

▲ The image is traced carefully through the transfer sheet.

▼ The umber colour is transferred, revealing the image on the paper.

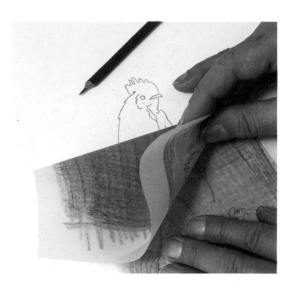

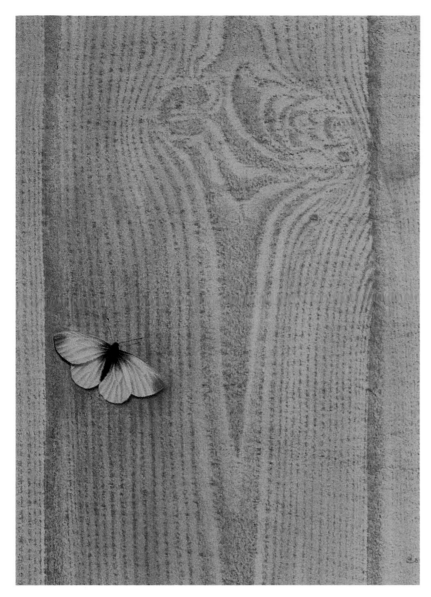

▲ **Wood White Butterfly**
Frottage
25.5 x 18 cm (10 x 7 in)
A butterfly-shaped piece of masking film was positioned before the frottage was rubbed. Once the paper was stretched and toned, the mask was removed and the butterfly painted with soluble graphite and Raw Umber watercolour pencils.

Masking film in paper stretching

Normally only used dry, masking film can be applied to good-quality watercolour paper before wetting and stretching it. The film can then be peeled off when the next stage of colour work is complete. This is especially useful when making a frottage where the white or colour of the paper is to be retained and painted on later, as in the painting of the Wood White butterfly shown here. If you are using thinner paper, it is a good idea to test this technique before doing your final artwork, as some thin papers have a coating that comes away as the masking film is removed.

Colour

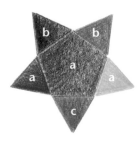
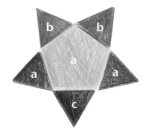

A mnemonic learnt at school – **R**ichard **O**f **Y**ork **G**ave **B**attle **I**n **V**ain – recalls the basic primary and secondary colours. As a beginner, you will not need many more colours than these, in spite of the great choice available to you. Part of the excitement of colour pencil work is in creating new shades by blending two or more colours together.

▲ These shapes show the three primaries with their associated colours:

a Primary colours
b Secondary colours
c Complementary colours

Basics

The primary colours of red, yellow and blue are those that cannot be mixed from any other colours. When any two primary colours are mixed, they form the secondary colours of orange (red + yellow), green (yellow + blue) and violet (blue + red). Tertiary or intermediate colours, such as orange-yellow or blue-violet, are made when a primary and a secondary are mixed together.

Complementary colours

These are pairs of colours that are opposite each other on a colour wheel. Green is the complementary of red, violet the complementary of yellow, and orange the complementary of blue. To enliven a painting and add colour contrast to it, put complementary colours next to each other. See how the colours sing.

Now blend one of the primary colours with just a little of its complementary. You will find that the primary can be subdued with this small addition. The more you add of the complementary colour, however, the more muted the primary becomes until a neutral, brownish tone results.

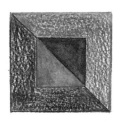

◀ The squares on the left show each primary colour with its complementary. The outer squares are drawn, while the inner squares are toned with water. The patches next to them show the 'muddy' colours derived from mixing primaries with their complementaries.

◀ Nature often places complementary colours next to each other, for instance yellow and mauve, as in this iris. The whole is sharpened with green – virtually a mix of yellow with the mauve.

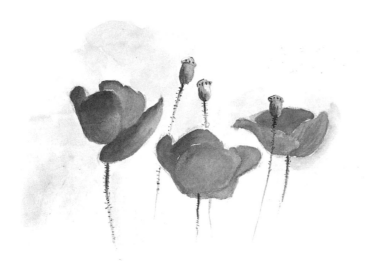

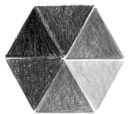

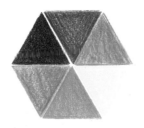

◄ This spontaneous watercolour pencil painting shows how the warm colour (red) advances while the cool colour (blue) recedes.

Colour temperature

Cold or cool colours visually recede and are associated with distance, whereas warm colours optically advance. A rich red poppy against a cool blue sky is a classic example. Examples of cold primary colours are Vermilion or Scarlet, Lemon and Cerulean. Warm versions are Alizarin, Cadmium Yellow and Ultramarine. By mixing either warm primaries or cold primaries together, you will achieve the clearest and cleanest blends. But if you mix a warm and a cold primary together, a dull, lifeless colour will result.

Suggested limited palette

Try to resist buying all the wondrous array of coloured pencils available. Initially restrict yourself to no more than ten of any one type, including a cold and warm version of each primary. The following should suffice: Lemon, Cadmium Yellow, Vermilion or Scarlet, Alizarin or Madder Carmine, Cerulean, Ultramarine, Raw Umber, Burnt Umber, Raw Sienna and 8B Dark Wash Soluble Graphite.

From these you can mix an infinite number of colours, shades and tints – greens from the yellows and blues, mauves from the blues and reds, and variations of orange from the reds and yellows. You can produce a lively black from Burnt Umber and Ultramarine – unlike the dead, lacklustre 'colour' that sometimes comes out of tubes. Add Cadmium Yellow to

▲ The diagram on the left shows the cool primary colours and their blends. The centre diagram gives the warm primary colours with their blends. The diagram on the right shows the results of mixing cool and warm primaries.

this mix for a lovely and variable olive green. The 8B soluble graphite pencil will tone the colours and blends and will also assist with granulation (speckled effect) where this is required when using water-soluble pencils (see page 37).

You will find that the order in which you blend colours can alter the finished effect. For example, yellow applied over red can look different from red over yellow, depending, among other things, on the opacity of the pencil and the pressure used.

◄ The result of mixing black with yellow (left) is an olive green. The second diagram shows the variable black that results from mixing Ultramarine Blue with Burnt Umber.

Tone

Examine the engravings of Dürer and Thomas Bewick or the more contemporary Eric Fraser and Charles Tunnicliffe. The tonal variety they achieve with simple linear marks is awesome.

Tone is usually accepted as a flat area of one shade, and tonal variety (or tonal range) as a gradation from light to dark. Sometimes 'tone' is described as colour mixed with grey, 'tint' as colour mixed with white and 'shade' as colour mixed with black. When black, grey and white are used alone, the drawing or painting is described as achromatic. This is not to be confused with monochromatic, which describes any one colour used alone.

Where possible keep the tonal range in your work simple. Three tones are basic, but five are sufficient. If you use too many tones, your paintings will lack contrast.

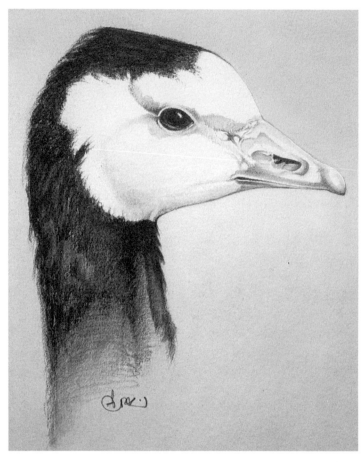

▼ Black and grey wax crayons were used to draw the trees and snow shadows and were softened with solvent on a brush. The final branches were drawn with a solvent-soaked rigger.

▲ **Barnacle Goose**
Watercolour and water-soluble graphite pencils
12.5 x 10 cm (5 x 4 in)
An achromatic illustration drawn and painted in water-soluble graphite with a tinted background.

▶ **Father, When Young**
Oil crayon
25.5 x 20.5 cm (10 x 8 in)
A bold, monochromatic portrait in oil crayon. I softened the scribbles and blocks of line drawing with solvent.

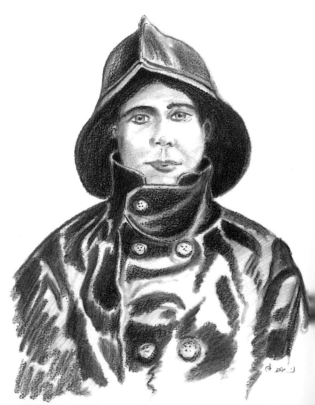

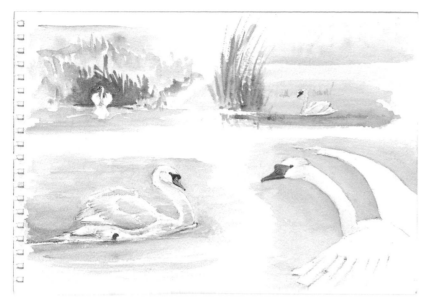

Tonal experiment

An easy and interesting experiment is to make an A4 size sample of both pure and blended colours. Have a black-and-white photocopy made. On the photocopy, note the difference in tone between the colours, especially the reds. Analyse these, noting the resulting tones of grey. This is a useful source of information for future reference.

Once in a while, get a black-and-white photocopy made of your own finished coloured paintings. You will be surprised – often pleasantly – at what you will learn about the range of tones that you used.

Tone and granulation

Charcoal and graphite are mentioned here because shades of grey are often easier to understand than tones of colour. Also charcoal and graphite encourage granulation. This is a condition that occurs when the colour from pencils separates or precipitates into small speckles of density when water is added. As charcoal and graphite contain minute insoluble particles, the granulation is more visible and gives more tonal contrast. The broken tone that is created indicates texture, whereas solid tone implies smoothness.

▲ Greens, pink, blue and black are used in the graphite sketch with watercolour pencil wash (top). Compare these colours to the black-and-white photocopy of the sketch to assess the different tones.

◄ Soluble graphite is shown to the left of the Ultramarine block and soluble charcoal to the right. Both have been blended with the blue to give improved granulated colours and tones.

Composition

Artists and photographers soon develop an eye for composition. If you have no previous experience, a few guide lines might be helpful. Invariably, paintings are half as long again one way as they are the other, in ratios of 6 to 4, 9 to 6 and 12 to 8 for example. But don't be discouraged from trying square or elongated formats: compositional theory will still apply.

Aid to composition

The main element of interest in any picture should not be central. The composition will be more satisfying if you offset it. It helps to divide the picture area into thirds. Where the lines cross are the points at which the main features would be best placed.

Using a viewing window will help you to decide on a good composition. Fix a piece of clear plastic film between a fold of card with two apertures cut in it to a ratio of any 3 to 2 combination. With a chinagraph pencil, mark lines on the film across all the one-third positions. When you view your subject through the film, the lines will assist your composition, whether you

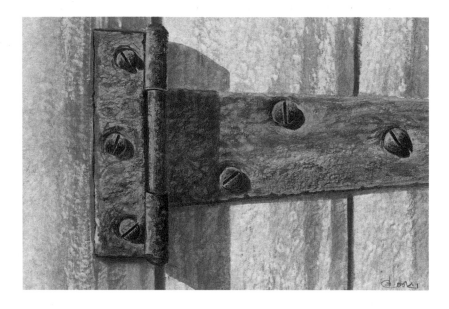

decide on a landscape or a portrait format. This simply made device will also help you if you are using a photograph as a source of reference.

If you are still doubtful about the best spot to place a subject of interest in a painting, draw it on a piece of tracing paper. Lay this over your background and move it about until you are satisfied with the position. You can then transfer it to your painting.

▲ **Rusty Hinge**
Watercolour pencils
10 x 15 cm (4 x 6 in)
The composition of this painting is based on the principle of dividing the picture area into thirds.

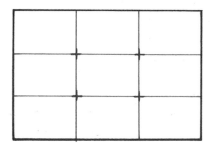

▲ On this simple compositional grid, prime points of interest are on any of the four crossing points shown in red.

▶ A useful visual aid can be made with folded card and clear plastic film with lines marked on it with a chinagraph pencil.

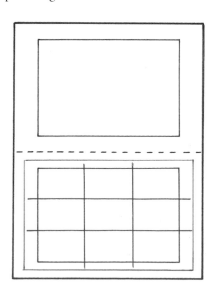

Structural lines

It is always helpful to look at other artists' work when exploring composition. Make a tracing of an Old Master's painting or a modern illustration and, with a ruler and pencil, mark through the one-third positions and any angles formed by the main lines of the image, as shown in the example. The results may surprise you, as they invariably show compositional theory in practice.

Geometric arrangements

In composing a picture, try to lead the viewer gradually into your work. Don't put barriers such as fences or closed gates in the way, and make the journey last, unless there is a good reason for getting straight to the point.

As you explore different compositions, consider geometric arrangements. Some Victorian artists liked to keep the main interest within an oval inside the oblong of the picture, for example. However, do not fall into the trap of restraint. Circular and triangular arrangements can be static if they are placed centrally in the picture. This is not true if they are offset, though. Circular strokes and marks carry the eye around the picture, while the elements of any group such as trees or people look more interesting in a triangular format than in a straight line.

Squaring up

Sketches or drafted compositions for a larger painting are often 'squared up'. Make a tracing and divide the image into squares or oblongs with a grid of crossed lines. Double the measurements of this grid and the picture will be twice the size in linear terms, but four times the original area. Note where the lines of your subject pass through the crossed lines and repeat them on the enlarged grid.

Alternatively, take your original drawing to a photocopy shop to enlarge or reduce it by any percentage required. You can experiment with sizes, ratios and composition.

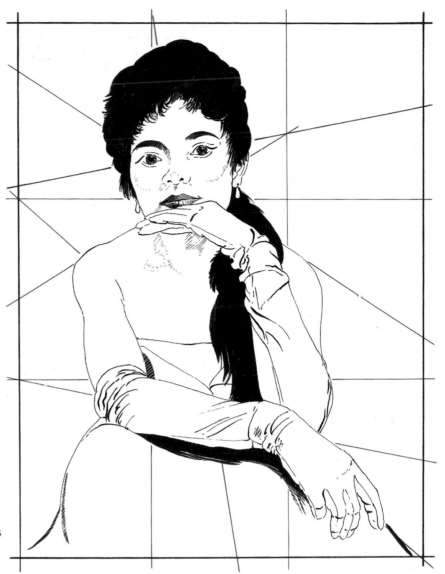

▲ This half-length portrait has been traced in ink and the compositional lines indicated in red. Note how the woman's right eye is virtually on a one-third spot. The blue construction lines indicate how the principal lines of the image coincide with some of the red compositional lines.

◀ The straight line arrangement on the left is static and uninteresting. The circular arrangement in the centre is better but still too 'organized'. The offset triangular format on the right is more satisfying.

Simple Perspective

As people, objects or buildings recede into the distance, they appear smaller. Distant features in a landscape also appear lighter than those in the foreground. In order to convey these effects in a drawing or painting, you will need to know the basic rules of perspective.

Linear perspective

The simplest form of linear perspective has a single vanishing point on an eye-level horizon. The eye-level is a horizontal line as seen by the viewer. This line will be higher if the viewer is standing up, mid-way if sitting down and virtually at ground level if lying down. Ground level is known as the base line.

The vanishing point is where all parallel lines appear to converge on the eye-level horizon and it can be inside or outside the actual picture area. The best-known example of a single vanishing point within a picture is a railway track running into the distance. To determine the spaces between diminishing horizontal lines such as the railway sleepers, draw a diagonal line through half of the first space. Continue the diagonal and where it crosses the opposite outer line, draw the next horizontal. Repeat as often as required.

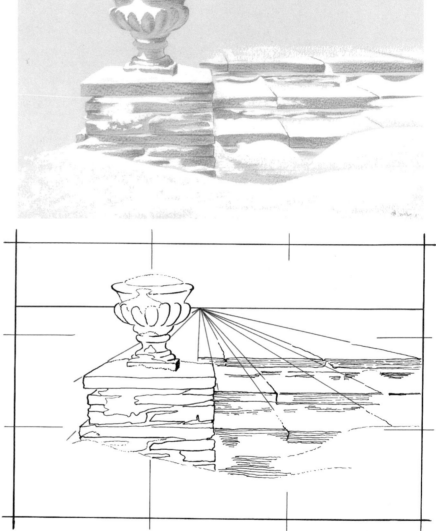

▲ These ornamental steps with drifts of snow rely on a single vanishing point to give them perspective, as shown by the blue lines in the tracing below the picture.

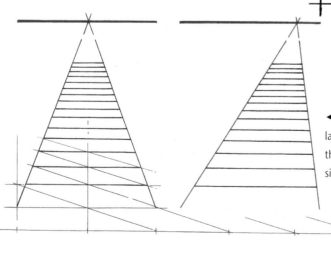

◄ A railway track or ladder disappearing into the distance illustrates a single vanishing point.

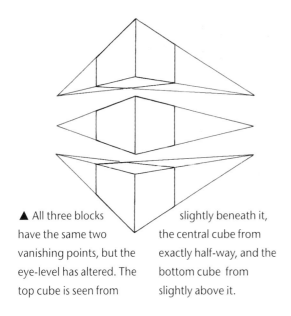

▲ All three blocks have the same two vanishing points, but the eye-level has altered. The top cube is seen from slightly beneath it, the central cube from exactly half-way, and the bottom cube from slightly above it.

Two sides of a house or three sides of a cube involve two vanishing points, whether looked at on the same level or from above or below. As before, these can be inside or outside the picture area. Even an arrangement of blocks of different shapes and sizes can be resolved with just two vanishing points.

As an exercise, draw a folded screen using two vanishing points. It is helpful to draw a plan of any object or building to base the perspective drawing on, as shown in the diagram below.

◄ A plan of the folded screen is shown above the perspective drawing to assist in determining which folds come forward and which recede.

◄ Like the screen, the drawing of the house uses two vanishing points.

▶ In this line drawing, three doors in an old house are shown at different angles, producing complex perspective. Try tracing the picture and ruling along the lines of the doors to find out where the vanishing points are.

▼ To assist in drawing a curve, reduce it to several flat planes. The blue construction lines indicate how each 'panel' has been placed in perspective. Here, the individual vanishing points are equal distances apart.

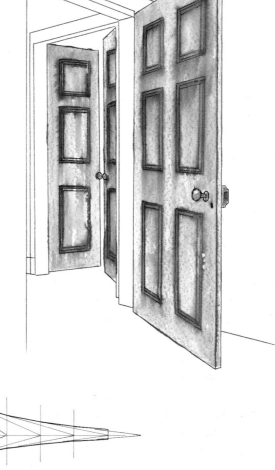

A curve can be difficult to draw in perspective. To simplify the process, reduce the curve to several flat planes and use three or more vanishing points, one for each plane. Work it out on tracing paper first, then transfer it to your drawing or painting.

Aerial perspective

Aerial perspective is the lessening of density and tone as a scene recedes into the distance. In any drawing or painting, closer objects should appear darker while distant ones are lighter. Colour also enhances this form of perspective. As mentioned on page 35, warm red colours advance and cool blue colours recede. So, at its simplest, aerial perspective can be implied by heavy red tones against hazy or pale blue ones.

Choosing a Subject

It's fun to travel, but you don't need to stray further than your own back yard or the window of your room to find a subject to draw or paint. Familiar items and views are often just as valid to use as subject matter – it all depends on how you look at them.

Starting points

There is no substitute for taking a sketchbook and going on location. However, if you are housebound for any reason, you can use photographs or even a video programme as a basis for an artwork.

Copying is a good starting point. Really, every artist copies. What else are you doing when drawing or painting a scene, flower or person in front of you? Many an art college encourages the copying of Old Masters – not to mimic the work, but to study style, paint application and composition. So, if there are drawings, paintings or photographs that you like, copy them, but as exercises only. Beware of infringing copyright: do not, knowingly, sell another person's original idea.

Gather interesting subject matter around you. Collect leaves, shells, pebbles, cut or dried

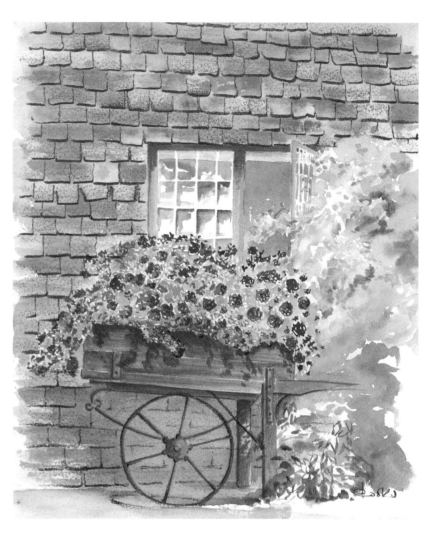

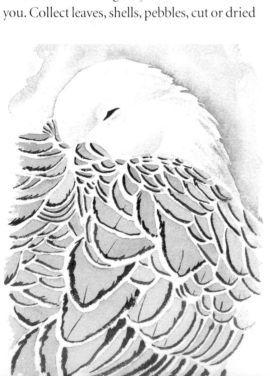

◀ Geese are among my favourite subjects. This monochromatic sketch of an Emperor goose has varying tones drawn and painted in water-soluble graphite. I enjoy the discipline of working within a limited range.

▲ **Hand Cart at Bateman's**
Mixed media
30.5 x 22.5 cm (12 x 9 in)
Contrary to my usual appreciation of nature over man-made objects, here the combination of multi-paned windows,

tile-hung walls and the old hand cart attracted me as a subject. I liked the apparently casual flow of continuous colour from the plants in the cart up into the climbing plants.

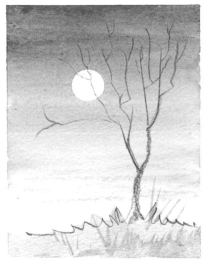

Graphite drawing with a watercolour wash brushed on top.

Ink with a watercolour wash on top.

Coloured pencil with a watercolour wash on top.

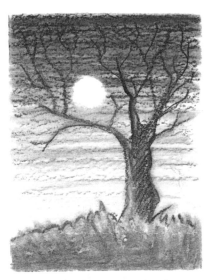

Crayon with solvent sprayed and rubbed on top.

Watercolour wash with watercolour pencils drawn and painted on top.

Smudged pastels with charcoal drawn and smudged on top.

flowers, fruit, a copper kettle, old lamps, and so the list goes on. If you have a pet, sketch and paint that. Look in a mirror: there is a sitter looking back at you and not as familiar as you might think! Really study your subject – it is the secret of all successful art.

Favourite subjects

You are likely to have an interest or hobby: flowers, old houses, animals or birds, trains, golf, even reading. It is amazing how much knowledge you have stored away in your brain about any favoured subject. Use it. Don't try

to paint a golf course if you've never played the game. However, a golfer who claims to have no drawing ability would be able to make a fair sketch of a number nine iron or a golf ball. So begin with a subject that really interests you. You'll have far more confidence before you even start than if you try to paint a dinosaur (unless you just happen to have a degree in palaeontology, that is!).

Consider, too, adopting variations of approach with the same subject matter. While still using pencils, add various media to give different finished results, as shown by the illustrations of the trees.

▲ These six comparison 'paintings', although identical in theme, have been done in various combinations of media. All had the sun masked out first.

◀ Japanese Maiko Girl
Mixed media
30.5 x 20.5 cm (12 x 8 in)
Whilst demonstrating in Kyoto in Japan, I was invited to a ceremony to bless and honour the year's new saki. The charming girl in this portrait guided me through the ritual of tasting the rice wine. Translated, the girl's name was 'Crane' and she wore an effigy of this bird on the front of her kimono.

▶ Kimono
Mixed media
35.5 x 15 cm (14 x 6 in)
Woven with gold, the Maiko girl's kimono was a lavish subject to paint.

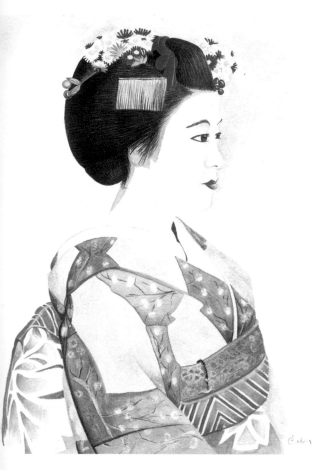

◀ Temple of the Golden Pavilion, Kinkakuji
Mixed media
30.5 x 22.5 cm (12 x 9 in)
Trying to capture the vibrancy of sun on beaten gold was a challenge. To be too brash would have spoilt the tranquillity and natural beauty of the setting. An hour later, it was snowing!

Working away from home

If you are able to travel, then exotic views, flowers, creatures and people await you. With coloured pencils you do not have to burden yourself with too much equipment. Adapt the paper palette described on page 26.

Using an A4 or A3 watercolour pad or book, rub on to a separate sheet, or on the back of the last sheet, patches of your own selection of colours from soluble pencils. If you only use half the sheet, add more patches until you have covered the whole page with squares of dry pigment. A brush or two and a small container for water: what more do you need?

On location, just wet your brush and lift off colour for your painting. You may not come back with a *Mona Lisa* or complete a Sistine Chapel, but your immediate notes or outdoor painting will be spontaneous and informative enough to work from if a larger painting beckons.

Interpretation and inspiration

Having chosen a subject and drawn and painted it in a conventional way, as well as perhaps varying the media, you could also consider new interpretations. Try looking at the familiar with new eyes. If possible, turn your back, bend over and look upside-down between your legs. Or, with your back to the view or object, look at it in a mirror. Upside-down or reversed, it's not so familiar now.

Look for abstract shapes in nature: the patterns and textures on a tabby cat, a zebra or a goose, perhaps, or the random markings on a feather or at the centre of a flower. Move in very close to well-known objects – fruit, crockery, even wallpaper. Cut a pair of L-pieces in card and look again at these familiar things or use the L-pieces to crop your own photographs. Select vertical compositions from horizontal pictures.

Inspiration comes in the most unlikely places and at odd times. Suddenly something catches your eye, an idea is born. Not just sight, but any one of your senses can spawn ideas for artwork. Capturing the citrus smell of lemons and oranges, the sound of bells on a moonlit night, the textural feel of an old stable door, the salty taste of a seascape are challenges enough.

Imagination

Artists, like authors, can work in fact or fiction. Use your imagination. Daydream, or read again the works of writers such as Lewis Carroll, Edward Lear or J. R. R. Tolkien. Make pictures of your dreams or the words you read. Be adventurous! Fantasy art, conjured up from the world of fairies, dragons, make-believe and storybook heroes, can spur your imagination. Such an approach may lead you in a direction you might not otherwise consider – even to book illustration perhaps. We all have imagination, some more vivid than others, but art, like literature, has no boundaries. Such as exist are of your own making.

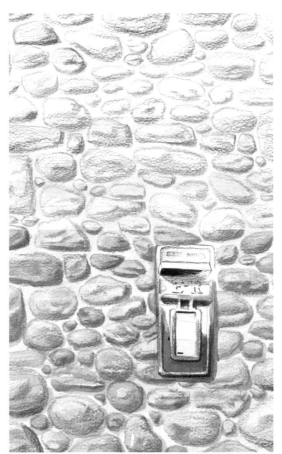

◄ **Letterbox in Wall**
Mixed media
30.5 x 22.5 cm (12 x 9 in)
I enjoy the juxtaposition of natural and man-made objects. In this progressive drawing/painting I have shown the four stages to completion, from the initial drawing at the top through the addition of washes and over-drawing to the finished detailed painting at the bottom.

◄ **Broken Road Sign**
Mixed media
30.5 x 20.5 cm (12 x 8 in)
There is a certain poetic justice when nature obliterates the decaying works of mankind. In a Cumbrian lane, I found this obsolete road sign being engulfed by grasses. I emphasized the flowing lines of these grasses against the angular structure of the sign.

Mixing Media

Usually associated with a combination of different drawing and painting media, the term 'mixed media' can also apply to coloured pencils. By using water-soluble and non-soluble coloured or graphite pencils together or in conjunction with ink or paint, techniques such as defined line, wax resist and frottage become possible.

Defined line

Also known as indicated line, this term describes drawings made from coloured or pencil lines overlaid with washes of watercolour or soluble graphite pencils. Ink, too, can be used for the line drawing. Waterproof ink and soluble ink give quite different effects, as shown in the two illustrations of the cockatiels.

▲ I drew the cockatiel on the left in waterproof ink and washed over it with watercolour and soluble graphite pencils. The bird on the right was drawn with soluble brown ink and also had a wash laid on it. As the ink was not waterproof, some delightful blends and 'happy accidents' occurred and enriched the study.

◄ I drew the bench and its shadow in non-soluble coloured pencils on a green-toned watercolour paper. I then painted both of them with Derwent watercolour pencils.

Wax resist

This technique recalls memories of childhood and drawing with a candle. Wax resist relies on the drawn wax image repelling water. Some non-soluble coloured pencils work almost as well as candles.

The illustration of a rowing boat was made by exploiting the waxy quality of a Derwent Drawing pencil used dry on the paper. This was overlaid with coloured and toned washes applied with a brush to enhance the light and shade. The mixes, made from dry patches of watercolour pencil and soluble graphite, are shown below the image.

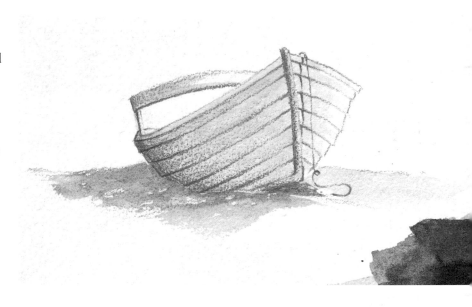

▲ This study in brown waxy Derwent drawing pencil was toned from patches of colour and graphite.

Frottage with other media

Wax resist is also the principle behind using frottage (see page 22) with a watercolour wash. If a waxy pencil or crayon is used for the frottage, it will repel the wash, which will only colour the parts of the paper left plain. The frottage pattern will be left showing clearly.

Frottage can form a very effective background to a painting, giving a realistic representation of a texture or pattern. The illustration of the hover fly, for example, shows a frottage of wood grain taken from a shed door. The Demonstration on page 58 uses frottage in a similar way and describes the technique in more detail. Both these paintings are completed with other media.

Examine different surfaces that might be suitable for frottage backgrounds: stone, tree trunks, leaves, frosted and patterned glass, even textured wallpaper. Touching is tactile and becomes addictive. You will not be able to pass another textured surface without running your fingers over it – just to 'see'. Graphite, used to record drain covers, is wonderful. Just bear in mind that, rather like a negative and a photograph, the image you record will be a reversal of the actual image. The shadow area between planks of wood, for example, will record as plain paper and will need to be drawn in.

Gouache, acrylic or oil paint is required to paint any image over the waxed and water-coloured frottage, unless the image was masked out with film or fluid before the frottage was drawn. Chromacolour, a water-based resin paint, can be used opaque or as a thin, transparent glaze to enhance a three-dimensional appearance as in the painting of the hover fly.

▼ **Hover Fly**
Frottage
20.5 x 25.5 cm (8 x 10 in)
I used a waxy coloured pencil to create the frottage of a wooden door. This was stretched, enhanced and washed over with watercolour. I then painted the hover fly in Chromacolour. I used thin glazes for the wings and shadow so that the wood grain would show through, but I painted the rest of its body opaque to cover the wax pencil.

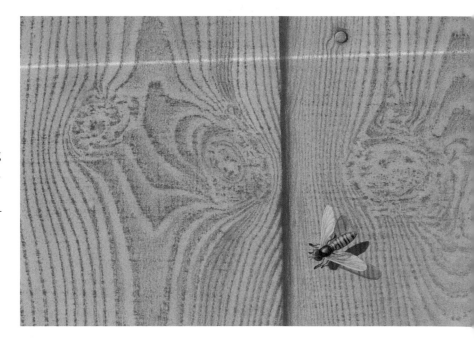

Mixed media exercise

Just for fun, try this exercise which combines various media and many different techniques. With two non-soluble coloured pencils draw the sections of the beach umbrella. Block them in with oil pastel. Use a non-soluble graphite pencil, waxy terracotta pencil, crayon or oil pastel to draw the umbrella stick. Wet the sky area with clean water and drop into it scrapings from an Ultramarine watercolour pencil. With a wet brush, dilute these over the umbrella. Lift out some clouds with a sponge or tissue.

Now wash over the beach area with more clean water. Scrape some Raw Umber watercolour pencil slivers into it and brush into a tone. Turn the picture sideways and start spattering wet-into-wet with various brown watercolour pencils and a soluble graphite pencil. Leave to dry. Re-spatter on to the dried variegated tone.

When it has dried, touch in the beach area at random with a clean wetted brush, indicating large stones and boulders. Scrape watercolour pigments and soluble graphite into these puddles of clean water. As they dry, stroke the lower parts with a damp brush to indicate shadowed areas. Add some tufts of grass.

▲ This exercise showing a beach scene makes use of a wide array of techniques and media.

◀ **Derwent Deer**
Mixed media
28 x 35.5 cm (11 x 14 in)
This illustration of a fallow deer is a mix of drawing and painting in which I used all the Derwent pencils – soluble and non-soluble – then available. The paper was left white where required.

48

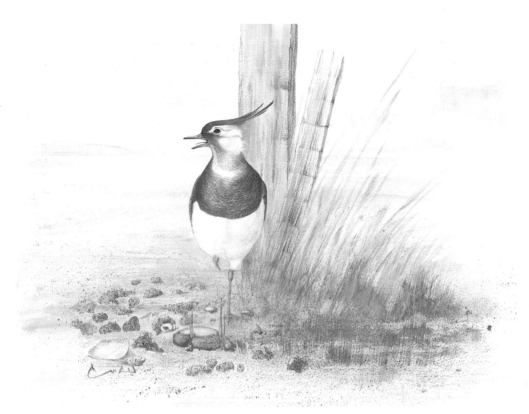

◀ **Transition**
Mixed media
25.5 x 35.5 cm (10 x 14 in)
This painting of a lapwing
is a mix of Derwent
coloured pencils, soluble
and non-soluble. Many
different techniques were
used to create it.

You have now completed a mixed media
pencil painting that incorporates many of the
techniques mentioned in the book. But every
painting does not benefit from using every
technique. Apply them with thought and
restraint. In the painting of a lapwing,
prepared for my second video, just about
every technique was used – including some
that space in this book prevents me from
mentioning. To my eye it shows.

▶ **Hunters**
Mixed media
30.5 x 25.5 cm (12 x 10 in)
I used pastel pencils to
draw the glove to suggest
both the texture and
weathered look of the
leather and suede. This
was fixed with a glaze of
Cryla acrylic which I used
in various thicknesses for
the rest of the painting of
the barn owl.

49

Bothy on Skye

This imagined scene was inspired by a drawing from one of my sketchbooks and illustrates the technique of impressing. A little forward planning is required to achieve the correct effect when using this technique. I worked with both Derwent Artist's and Studio pencils, selecting the same colours of each. For impressing and for detailed work I used the Studio pencils, while for broader applications I chose the Artist's pencils.

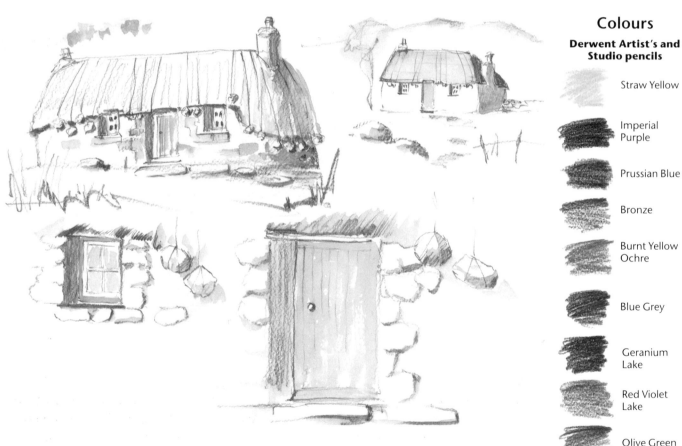

▲ First stage

Colours

Derwent Artist's and Studio pencils

Straw Yellow

Imperial Purple

Prussian Blue

Bronze

Burnt Yellow Ochre

Blue Grey

Geranium Lake

Red Violet Lake

Olive Green

Brown Ochre

Copper Beech

French Grey

First Stage

The sketchbook drawing I chose for my scene was done in soluble graphite and watercolour pencils. The interesting aspect of the bothy was the way in which the thatch was secured by ropes with large stones to weight them down. I intend to show the ropes by using the impressing method.

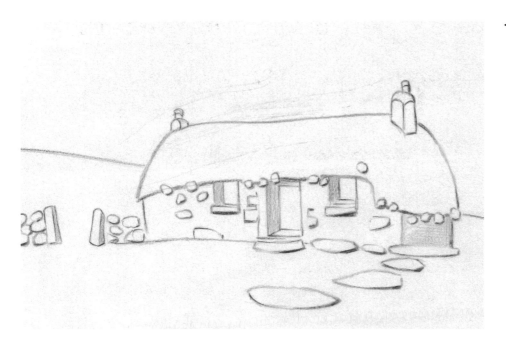

◀ Second stage

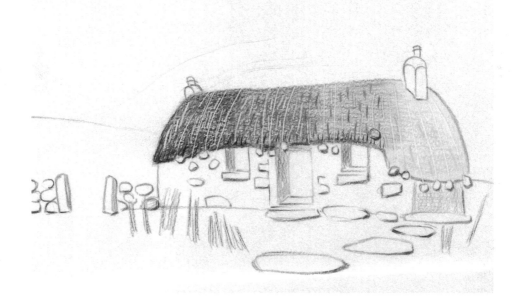

◀ Third stage

Second Stage

I made an initial drawing on Bockingford 300 gsm (140 lb) Not watercolour paper, using a Bronze Studio pencil. Corrections could be made at this stage, as the colour would not distract from the finished artwork.

Third Stage

Using a fine meat skewer and working through thin tracing paper with the lines indicated on it, I impressed the paper to show the ropes on the thatched roof. Progressing in stages from right to left, I now began colouring in the thatch. I used a Straw Yellow Artist's pencil at the far right, then impressed at random over the thatch with a Straw Yellow Studio pencil. I coloured over these marks with Artist's Brown Ochre, then impressed – again at random – with Studio Brown Ochre. I repeated this with the Burnt Yellow Ochre and Copper Beech pencils. Moving to the foreground, I impressed some grass with the skewer and roughly coloured it with an Olive Green Artist's pencil.

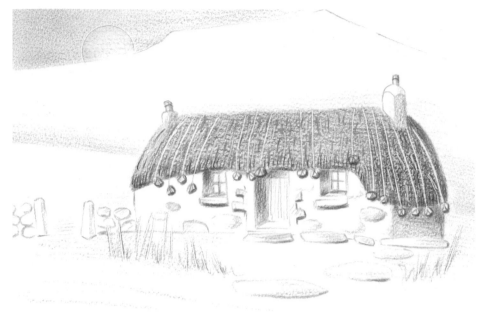

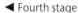

Fourth Stage

I emphasized the stones at the ends of the impressed ropes with a Bronze pencil, adding more Bronze to the sides of the chimneys and the bothy, and to the flagstones in front. I used Blue Grey on the chimney pots, window and door recesses, window sills and the right wall of the bothy. Changing to French Grey, I shaded some of the stones in the bothy wall. Using a stencil to define the line of the mountain ridge and to protect the rest of the drawing, I indicated the sky in Prussian Blue. After fixing a round sticky label across the ridge to mask out the moon, I started to rub in the Prussian Blue with my finger. I lightly coloured the foreground with Olive Green, then used Red Violet Lake and Imperial Purple to colour the lower mountain. I used Geranium Lake for the windows and door.

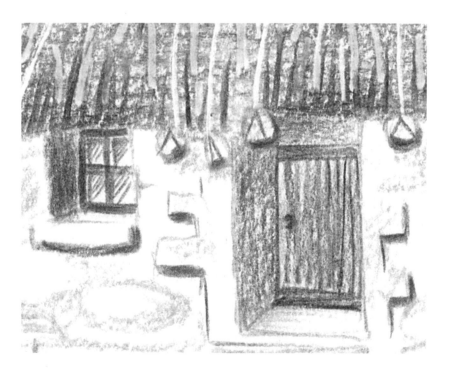

► Detail of the finished painting

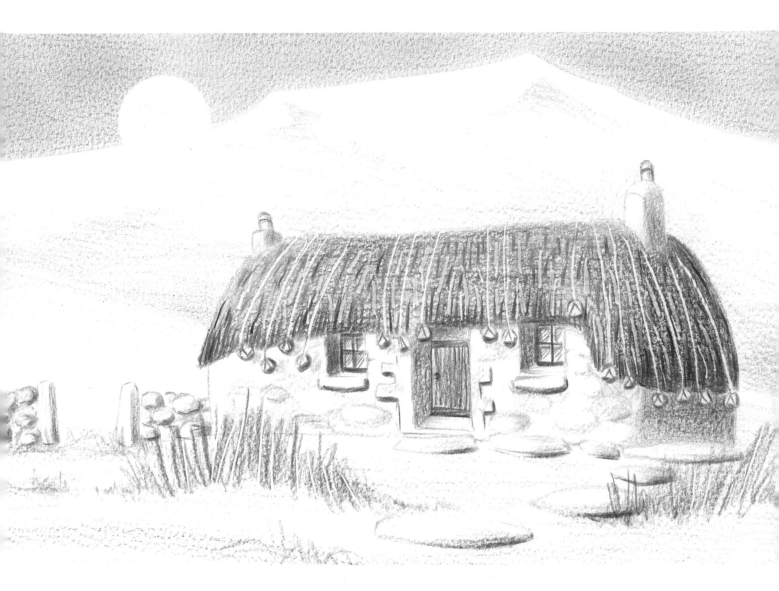

Finished Stage

Continuing to rub the Prussian Blue in with my finger, I finished the sky, relying on the stencil to give a sharp edge to the mountain. Where necessary, I increased the depth of all the colours in the bothy and the thatch. Extra stones were added and suggested in French Grey, while Blue Grey strengthened the shadows on the bothy and its adjoining wall. I added Copper Beech to the hanging stones and flagstones. In the foreground, I used more Olive Green to develop the grass. After adding more Red Violet Lake and Imperial Purple to the lower mountain, the finishing touch was to remove the round mask to reveal the moon.

▲ **Bothy on Skye**
Coloured pencils
18 x 25.5 cm (7 x 10 in)

Canada Geese

*The technique known as sfumato (see page 23)
was used for this demonstration worked in two shades of pastel
pencils. To add an element of contrast, the goose in the
foreground was masked out and drawn in separately on to the
white paper, while the goose in the background was
lightened with an eraser.*

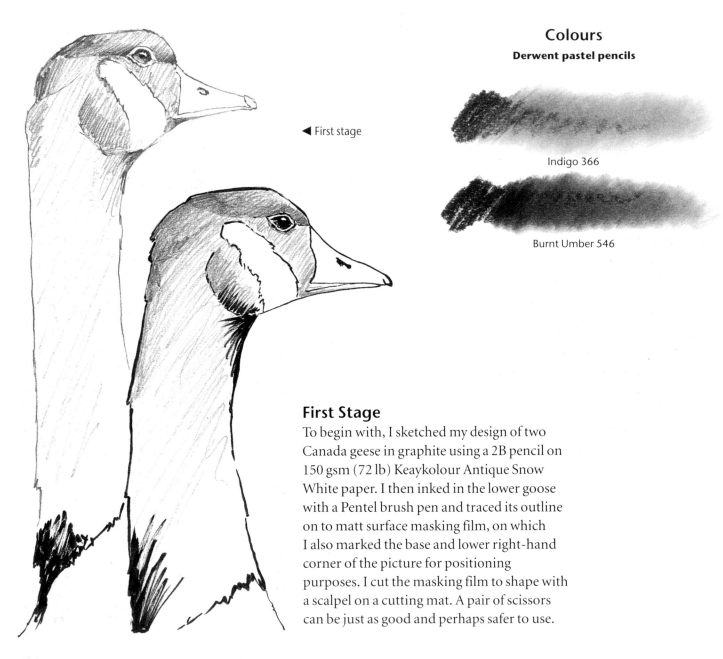

Colours

Derwent pastel pencils

Indigo 366

Burnt Umber 546

◀ First stage

First Stage

To begin with, I sketched my design of two
Canada geese in graphite using a 2B pencil on
150 gsm (72 lb) Keaykolour Antique Snow
White paper. I then inked in the lower goose
with a Pentel brush pen and traced its outline
on to matt surface masking film, on which
I also marked the base and lower right-hand
corner of the picture for positioning
purposes. I cut the masking film to shape with
a scalpel on a cutting mat. A pair of scissors
can be just as good and perhaps safer to use.

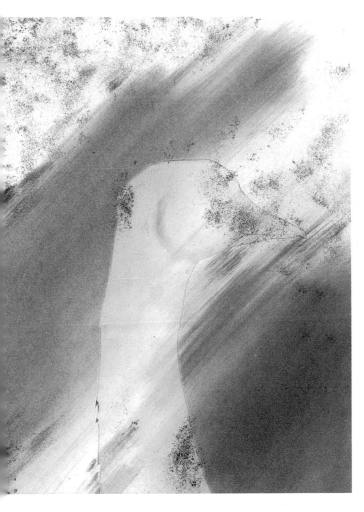

Third Stage

I continued rubbing the two colours of pastel dust into an even tone, blending them where they overlapped. The density could be deepened by scraping more pigment on to the paper and rubbing it in, or lightened by dabbing at it with a piece of bread. You might find that small, sharp edges of masking film lift as you rub in the dust. Avoid this by rubbing away from the mask in all directions. For this technique, masking film is preferable to masking fluid. Fluid can be inadvertently dislodged or completely removed when the dust is rubbed in.

Second Stage

Taking another piece of the same paper, I put 2.5 cm (1 in) strips of masking film around the picture boundary to keep the edges clean. I removed the backing sheet from the goose shape and accurately positioned the masking film. I then scraped pigment dust from the tips of the Indigo and Burnt Umber pastel pencils and began to rub the colours into the paper with paper towel. Don't worry about any streaks that appear as you do this, as they will tone evenly with further rubbing.

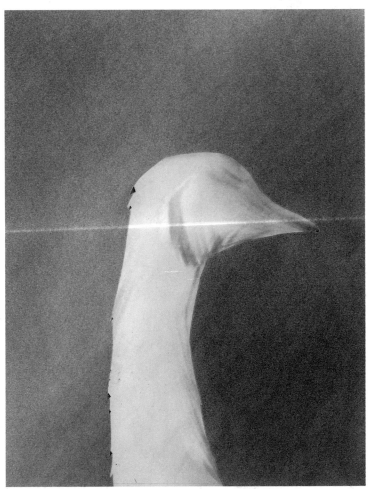

▶ Third stage

55

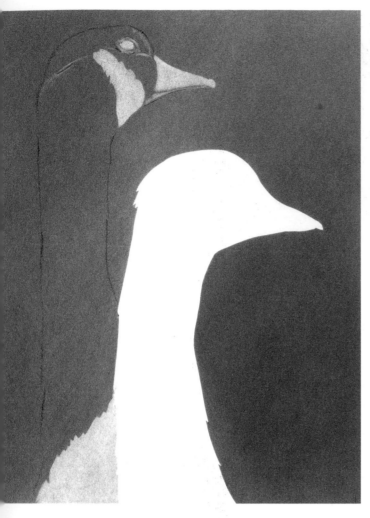

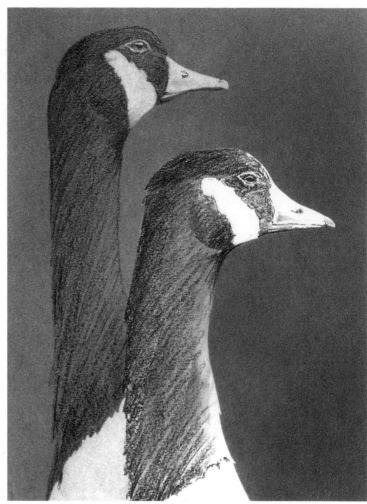

Fourth Stage

With the Indigo pastel pencil, I indicated the
upper goose, then began to lighten and
remove pigment from it using a kneadable
and a plastic eraser. To cut in the beak shape,
I used a piece of cut paper as a stencil. For the
eye and light patch on the cheek, I cut another
stencil, this time from thin card so that I
could rub more firmly to get as white a tone as
possible. I removed the masking film from the
lower goose to reveal the pure white paper.
Notice the marked difference in 'whiteness'
between this and the areas rubbed away on
the other goose.

Fifth Stage

I drew in the dark tones of the upper goose
with the Indigo pastel pencil, hatching in the

feather lines on the neck and drawing in the
beak. On the eye, I indicated the pupil and
lifted out the light ring further with an eraser.
Sketchily, I added tone and detail to the lower
goose, using the Burnt Umber pencil. The
difference in contrast between the two birds
was beginning to show.

▲ Fifth stage

▲ Details of the finished
painting

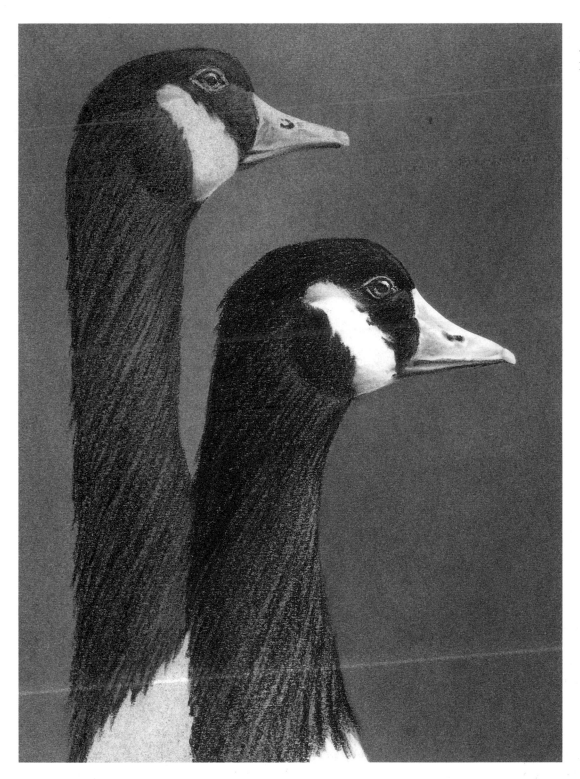

Finished Stage

I continued to work on both geese with the pastel pencils, using slivers from the eraser for detailed light areas. For controlled smudging, I twisted paper towel, using it clean to lighten or rubbing it on to the points of the pastel pencils to darken. The beaks show this technique well. In the finished drawing, the difference in contrast between the two geese is apparent. In the details opposite, compare the eye that was lifted out and cut into the toned paper (left) to the one drawn and smudged on to clean, previously masked paper (right). The lower one looks more 'alive'.

Shadows

*This demonstration combines frottage with painting
and uses a variety of media: Caran d'Ache wax oil crayons,
Derwent Drawing pencil, watercolour pencils and Chromacolour
paint. The frottage creates a very realistic wooden door
which is then painted with transparent shadow
and opaque images.*

▲ First stage

Colours

**Derwent
Drawing pencil**

Brown Ochre

**Derwent
watercolour pencils**

Burnt Umber

Raw Umber

Olive Green

Chromacolour

Cadmium Yellow

Payne's Grey

Yellow Ochre

Burnt Sienna

White

Prussian Blue

Parchment

Caran d'Ache wax oil crayons

Ochre

Natural Umber

First Stage

Choosing a combination of suitable sketches,
I squared them up (enlarged them) so that
I could compose my final design. I wanted
this to fit a life-size frottage of wood grain
taken from a shed door. I intended to make
several frottages to begin with, so that I could
select the one that looked most suitable for
the background.

Second Stage

For successful frottage in which all the detail
is retained, the best paper to use is one that is
thin, yet withstands immersion in water and
stretches well. I used a 100 gsm (47 lb)
stationery paper – Croxley Supreme

▲ Second stage

Third Stage

▲ Third stage

'Hammer surfaced' paper, which has a surface akin to watercolour paper. Having recorded several areas of wood grain, I chose the one made with a Caran d'Ache Neocolor 1 wax oil crayon in Ochre as this effectively gave a wax resist image (top left). I enhanced the image by indicating the shadowed recesses (bottom right). Freehand, I added extra drawing with the wax crayon and a 'waxy' Derwent Drawing pencil in Brown Ochre.

Once the frottage was complete, I stretched the paper and left it to dry. I then rewet it with a Rowney 60 mm (2⅜ in) hake and added a background of Raw Umber by scraping pigment from the tip of a watercolour pencil and brushing it in. In the same way, I added Olive Green to the lower part. To the left you can see particles of pigment scraped in, to the right the brushed-in colour.

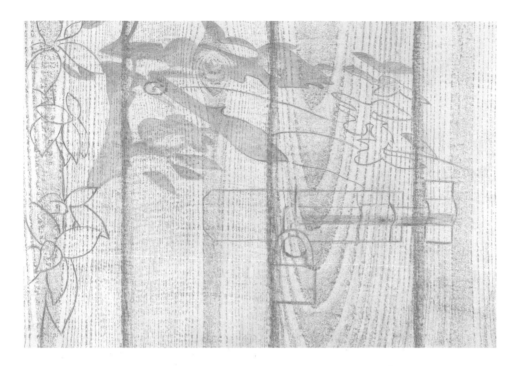

▲ Fourth stage

Fourth Stage

With a dry Raw Umber watercolour pencil, I indicated the cast shadows of a honeysuckle. This added interest to the otherwise plain wood grain. With a wet Dalon No. 8 round brush and a paper palette of Raw Umber, I lightly painted in some of these shadows, allowing the frottage to show through. I used the same Raw Umber pencil to draw the leaves and to outline the bolt and padlock.

Fifth Stage

I continued painting, using the No. 8 brush and a No. 3 for smaller details. I underpainted the leaves in Chromacolour with a mixture of Cadmium Yellow and White, adding Olive Green watercolour pencil in the shaded areas. Where the honeysuckle shadows crossed the depressions in the wood, I darkened them with a Burnt Umber watercolour pencil. Using a mix of Payne's Grey, Prussian Blue

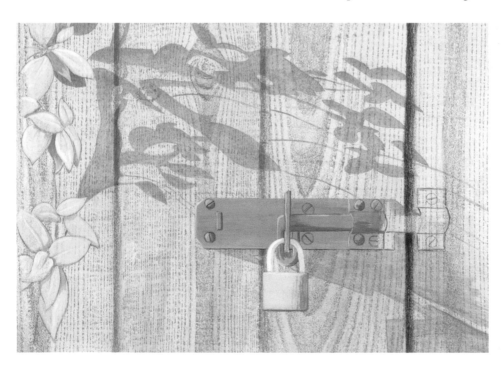

◄ Fifth stage

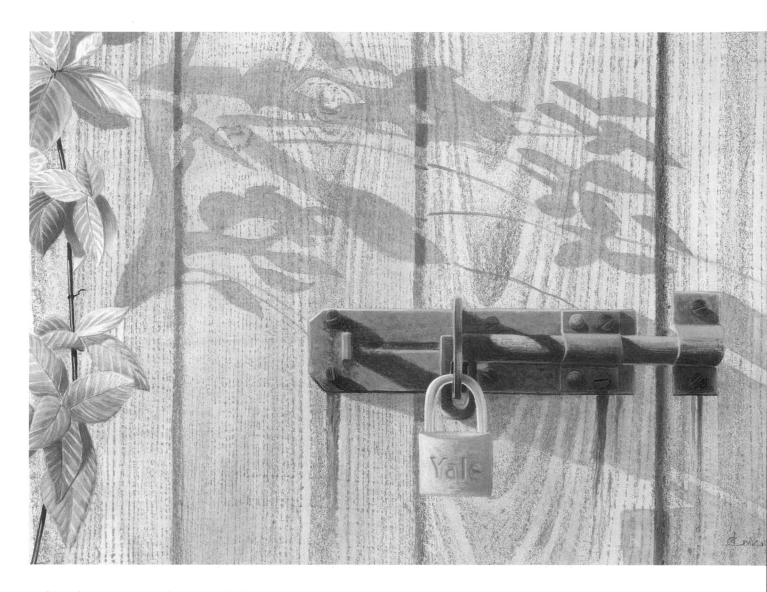

and Parchment, I started to paint the bolt, which I had drawn in some detail. The padlock was filled in with a mix of Cadmium Yellow and White with Yellow Ochre. I drew in the cast shadow under the bolt with dry Raw Umber watercolour pencil and, as before, painted it from a paper palette. I decided to emphasize and darken the gap between the door and the shed with a Natural Umber wax oil crayon, allowing the Ochre to show through.

Finished Stage

To give detail to the leaves, I painted them with a Dalon No. 1 rigger, using the same mixes as before. I added Burnt Sienna blended with Cadmium Yellow to indicate the leaf spines and the main stem of the honeysuckle. I then concentrated on the bolt and padlock, mixing a little Olive Green with the yellow and white for the highlights on the bolt. For the rusty screws, I added Burnt Sienna to the yellow and white mix. As Chromacolour is a water-soluble resin, it dries quickly and is then waterproof. I was therefore able to add glazes of Burnt Sienna to the screws, also indicating some rust runs beneath the bolt. I also glazed on the Payne's Grey, Prussian Blue and Parchment mix to strengthen the cast shadows on the bolt. I completed the padlock, mixing yellow, green and blue with a lot of white for the shackle. Finally, I indicated the letters on the padlock.

▲ **Shadows**
Frottage and mixed media
25.5 x 35.5 cm (10 x 14 in)

Butterfly and Daisies

*This painting was created with three colours of
watercolour pencils and a water-soluble graphite pencil.
The white of the background paper also played an important
part. Although water was used, the painting retains elements of
drawing and dry colour within it. Not every linear mark
needs to be dissolved into a tone.*

▲ First stage

First Stage

I made a drawing on Bockingford 535 gsm
(250 lb) Not watercolour paper the same size
as the final painting and inked the outlines of
the shapes to be masked. I then made tracings
of the shapes on to matt masking film and cut
them out with a scalpel on a cutting mat.

Second Stage

On another piece of the same Bockingford
paper, I placed strips of masking film around
the boundary of the artwork to keep the edges
crisp. I removed the backing from the cut
shapes and positioned them on the paper,
using a template cut in tracing paper as a
guide. With a Dalon 25 mm (1 in) flat brush,
I wetted the paper with clean water and then
scraped particles of Deep Cadmium
watercolour pencil on to it with a scalpel.
I dissolved these cuttings into the water with
the same brush. While the paper was still wet,
I repeated this with the Olive Green, blending
the two colours together with a Daler No. 6
fan brush.

Colours

**Derwent
watercolour pencils**

Deep Cadmium

Olive Green

Raw Umber

**Derwent water-soluble
graphite pencil**

8B Graphite, dark wash

▶ Second stage

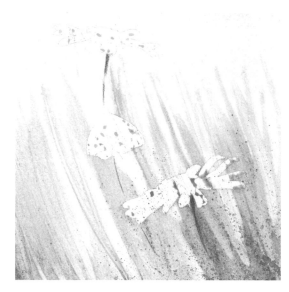

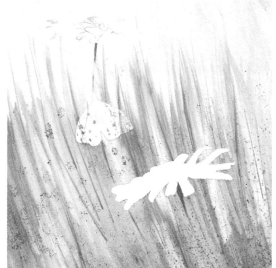

▲ Third stage

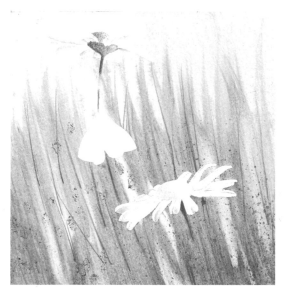

◀ Fifth stage

Third Stage

Using the flat brush side on, I swept the green into the yellow to indicate blades of grass. When the grass had dried, I drew the stalks with the Olive Green watercolour pencil used dry. To break the long line of the upper stalk, I swept clean water across it with a Dalon No. 7 round brush. Using the same brush, I spattered Olive Green across the lower part of the painting.

Fourth Stage

With Olive Green on a Dalon No. 1 rigger brush, I stroked in some fine grass blades. When these were dry, I sparingly daubed damp patches of moisture on to the lower left of the painting. Into these I scraped dry particles from the Olive Green pencil to give the texture of grass seeds. After blowing away unwanted pigment from the dry areas, I removed the flower masks and started to draw the upper flower in Raw Umber. I drew the central florets in dry yellow and toned them with the damp No. 7 brush.

Fifth Stage

I painted the daisy with a Rowney No. 3 Kolinsky sable brush by dissolving the Raw Umber and blending it with the yellow of the centre. Using a paper palette, I made various

blends of all three colours for the petals. When the yellow centre had dried, I drew individual florets with the dry Raw Umber pencil. I then started the lower flower, working as before. Finally, I removed the butterfly mask.

Sixth Stage

With the flowers finished, I lightly drew the butterfly's markings, head and body with the three watercolour pencils used dry. With the 8B soluble graphite pencil, I indicated the markings on the wings and antennae. Leaving the left side of the butterfly as dry drawing, I began to dissolve and blend the colours and graphite on the right with the dampened No. 7 round brush and the No. 3 sable.

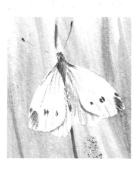

▲ Sixth stage

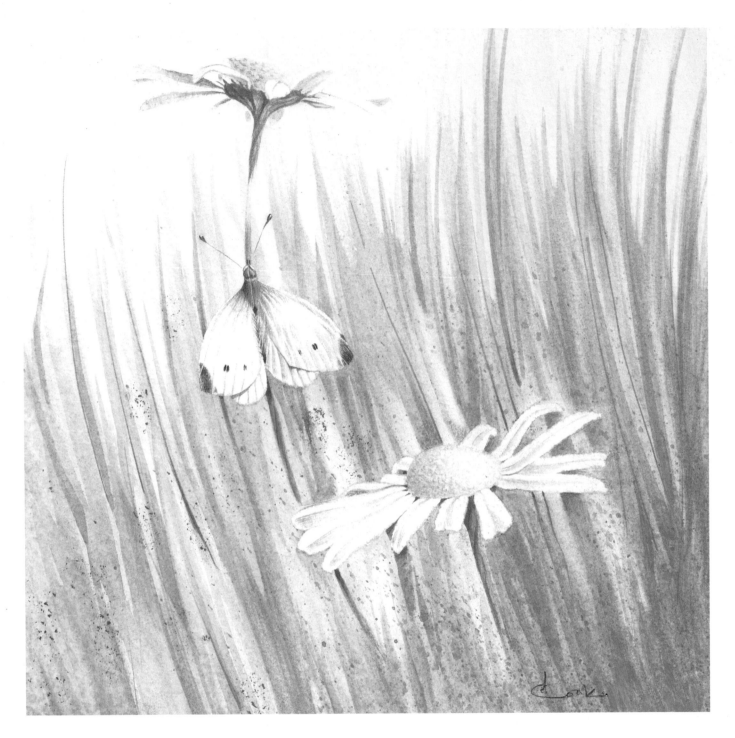

Finished Stage

I softened some of the background grasses
with the damp No. 7 round brush and
strengthened others with the No. 1 rigger.
Continuing the butterfly, I blended and lifted
colours and graphite from a paper palette
with the No. 3 brush. I finished painting in
the fine details with No. 2 and No. 0 round
sable brushes. Finally, I lightly drew some
hairs on the butterfly's body with dry pencil.

▲ **Butterfly and
Daisies**

*Watercolour pencils and
water-soluble graphite*
20.5 x 20.5 cm (8 x 8 in)